you've
got this!
(because God's
got you)

52 Devotions to
Uplift & Encourage

you've got this!
(because God's got you)

KariAnne Wood

TYNDALE
MOMENTUM®

*The nonfiction imprint of
Tyndale House Publishers, Inc.*

Visit Tyndale online at www.tyndale.com.

Visit Tyndale Momentum online at www.tyndalemomentum.com.

Visit the author's website at www.thistlewoodfarms.com.

TYNDALE, *Tyndale Momentum*, and Tyndale's quill logo are registered
trademarks of Tyndale House Publishers, Inc. The Tyndale Momentum logo
is a trademark of Tyndale House Publishers, Inc. Tyndale Momentum is the
nonfiction imprint of Tyndale House Publishers, Inc., Carol Stream, Illinois.

You've Got This (Because God's Got You): 52 Devotions to Uplift and Encourage

Designed by Libby Dykstra

Edited by Stephanie Rische

Published in association with the literary agency of William K. Jensen
Literary Agency, 119 Bampton Court, Eugene, OR 97404

For information about special discounts for bulk purchases, please
contact Tyndale House Publishers at csresponse@tyndale.com, or call
1-800-323-9400.

ISBN 978-1-4964-3064-9

Printed in the United States of America

24 23 22 21 20 19 18
8 7 6 5 4 3 2

To my brother Mark:
You are the adventure planner,
the scrap-wood saver, the laugh
sharer, the storyteller, and the leader
of your own band of merry men.
Thank you for believing in me.
Thank you for inspiring me.
Thank you for filling the shoes
left behind by a giant.
You are my heart.

Introduction

I ALMOST MISSED IT.

In the middle of a day filled with the busyness of life—a trip to the craft store and five yards of orange pom-pom fringe and a hair "don't" of oddly bobby-pinned bangs and stacks of dishes and ten minutes spent chasing the dog around the yard—it almost got lost.

A tiny pink Post-it note.

With its crumpled edges peeking out from behind the computer, it looked a little bedraggled. I tugged at the corner of the note, pulled it loose, and smiled. Scrawled across the small square were the encouraging words my daughter had written and then tucked away for

me to find. It read "You've got this, Mom" next to a sideways smiley face.

And she was right. I had this—because God was there first.

The truth?

Sometimes life can be challenging and overwhelming as we gaze out at the storm clouds circling in the distance. Sometimes the road ahead isn't one we would have chosen, and our hearts are heavy. Sometimes the burdens we're carrying are crushing us under their heavy load. And sometimes?

God seems so far away.

This book is a collection of devotionals that remind us that God is always by our side. He wants to lift our burdens and dispel the storm clouds and ease our heavy loads. He loves us when we feel unlovable. He lifts us up and gives us a peace that passes all understanding. And in the midnight of every dark moment, God is there.

This is my prayer for you: I pray that the words written on these pages would pour joy into your heart and fill you with comfort and reassurance. I pray that your weary spirit would

be encouraged and uplifted and restored. I pray that this message will speak to your heart and remind you of the unconditional love God offers to you every single day.

This book can be used in whatever way fits you in this season of life. There are fifty-two devotions, and I invite you to read one each week throughout the year. You may also want to pick the topics that fit what you're going through right now, or you can simply read the book cover to cover at your own pace. May the devotionals on these pages remind you that you are not alone. God is with you always.

Lay down your challenges and your burdens.

Lay down your tiredness and your weariness and all your tomorrows.

And rest in his promises . . . because God's got you.

KariAnne Wood

Because Some Days Are Poodle-Haired

This is the day the LORD has made;
let us rejoice and be glad in it.

PSALM 118:24

YESTERDAY WAS JUST one of those days—a day when everything went wrong and nothing went right. I overcurled my hair so it closely resembled a poodle's and forgot to set the timer on the coffeemaker and ran into a sticky spiderweb and just missed the 90-percent-off sale in the clearance aisle at Hobby Lobby. I awkwardly wasn't funny when I thought I was going to be, and on five different occasions I opened my mouth and inserted my foot.

I was still frowning when I arrived to pick up my daughter Whitney from basketball practice that afternoon. As she slowly climbed into the car, I sighed impatiently. Then I made my way down the back roads to our farmhouse while the same thought kept spinning around in my head like a chorus in a song: *Why?* I thought. *Why did a day like this have to happen to me? Where's the sunshine?*

When we pulled up to the house, I grabbed my bags, shut the door, and stomped up the sidewalk. I got to the top step of the porch, turned around, and yelled across the yard: "Whitney! Where are you? We only have a few minutes before we have to leave for your brother's game. WE ARE GOING TO BE LATE."

A tiny giggle came from behind the car. "Hold on, Mom. I'll be there in just a sec." Then Whitney bounded up the sidewalk, grinning from ear to ear.

"Wait until you see this!" she said, holding out her phone. "You won't even believe it."

Irritated, I glanced down, expecting to see a social media post or a joke or something she thought was funny.

But instead?

It was a photograph she'd just taken of the sky overhead—an incredible, amazing, awe-inspiring glimpse of God's handiwork, with beams of sunlight dancing through the clouds. My anger melted away. This glorious scene had been unfolding in the sky before me, and I'd been so focused on myself and my hair and my clearance-aisle mishap that I almost missed the amazing right in front of me.

How often do we turn our gaze inward and overlook the beauty our heavenly Father has prepared for us? How often do we concentrate on the things of this world instead of turning our eyes to what's truly important?

Whatever you're facing today, take time to look up and remember that God's big enough to handle it. Even if your hair has gone poodle on you.

*Dear Lord, help me to turn my focus on you.
Even on days when the storm clouds gather,
I know you have your hand on me. Amen.*

The Day I Forgot My Skirt

*As the clay is in the potter's hand,
so are you in my hand.*

JEREMIAH 18:6, NLT

I STARTED MY BLOG WITH LOFTY AMBITIONS.

I had big plans. I was going to write a blog about decorating—the kind of decorating you read about in magazines. I was going to opine on neutrals and how to fit them into your decor. I was going to discuss in great detail the height of a chandelier over the dining room table. The blog would be full of well-written posts on color choices and design trends and why shag carpeting was so 1972.

I knew I needed to start with pictures. But

the only camera I owned was the kind you threw away after you used it, so I hired a photographer to come to my house and take photographs of my Christmas decorations. When the pictures came back, I was in awe. They were the most beautiful photographs I'd ever seen.

I couldn't wait to show them to the world.

I gathered my photographs and my courage and my overflowing bucket of optimism and sat down at the computer to write the first post. I uploaded the first picture and started typing a lengthy essay on how gray and silver were the go-to Christmas colors of that year. And then? I noticed something that made me cringe— something that made me hang my head and rethink my entire blogging career.

There in the photo was the living room with its decked halls. The garlands were wrapped around the banister. The stockings were hung by the mantel. And in the very center of the room, under my tree where a tree skirt should have been, were the most gigantic plastic tree-stand feet you've ever seen in your entire life.

Somewhere along the way, I'd forgotten my Christmas tree skirt.

The blog I started wasn't the one I intended to publish. Instead, I wrote about imperfection and decorating mistakes and the fact that my Christmas tree was naked at the bottom. And with every line, every word, every misstep, I found my voice.

God created us all to be unique. He is the potter; we are the clay. He gave each of us talents and gifts and our own individual strengths. God never intended for us to compare ourselves with others or to long to be like someone else. He wants each of us to embrace the person he designed us to be.

Even if you have a Christmas tree that needs to get dressed.

Lord, thank you for making me unique.
Thank you for the gifts you've given me.
Let me use those gifts to honor you today. Amen.

God never intended for us to compare ourselves with others or long to be like someone else.

He wants each of us to embrace the person he designed us to be.

Never Underestimate the Power of a Raisin Cake

*A gentle answer turns away wrath,
but a harsh word stirs up anger.*

PROVERBS 15:1

MY TINY FOUR-FOOT-TEN-INCH-TALL grandmother was full of surprisingly helpful unsolicited advice. She told me that bangs are overrated and that a soda tastes better through two straws and that the way to a man's heart is through his stomach.

She must have been related to Abigail.

Abigail's story is recorded in 1 Samuel 25. She is an inspiration, both from a hospitality perspective and from a wisdom perspective. Her husband Nabal? Not so much.

Before David was king, he and his men protected Nabal's sheep while camping out in the wilderness. When it was time for Nabal to shear the sheep, David sent messengers to Nabal asking for some meat. You'd think Nabal would have been grateful. You'd think he would have sent some lamb along with fresh bread and a few grapes for all David's trouble.

You'd have thought wrong.

Nabal yelled at the messengers, kicked them to the curb, and said a few choice words that no respectable Old Testament character should say. David was insulted. David was mad. So he gathered four hundred men, equipped them with swords, and prepared to storm Nabal's house.

Enter Abigail . . . and some food. Her grandma must have passed on words of wisdom to her, too.

She gathered bread and meat and figs and roasted grain and raisin cakes, and then she loaded up the donkeys to meet David. When she reached him, she fell on the ground before him and asked him for mercy: "When the Lord

your God has brought my lord success, remember your servant" (1 Samuel 25:31). David was moved by her heart and her contrition on her husband's behalf. He pardoned Nabal, and her family was saved.

The most incredible thing about Abigail wasn't her quick thinking or her gentleness or her ability to rock a raisin cake; it was the fact that she met wrath with kindness. She could have responded to David with a sharp tongue or followed her husband's lead and reacted in anger.

But instead? She placed the situation in God's hands and chose kindness. She humbled herself and allowed herself to become vulnerable. Rather than replying in anger, she responded to harsh words with grace and hospitality. In return, God blessed her and her house.

And every one of those raisin cakes.

Lord, soften my heart. Forgive me for responding in anger to those who have wronged me. Please teach me grace and humility instead. Amen.

Twinkle, Twinkle, Little Sky

Lift up your eyes and look to the heavens:
Who created all these? He who brings
out the starry host one by one and
calls forth each of them by name.

ISAIAH 40:26

SOMETIMES ALL IT TAKES is a burned marshmallow to put everything into perspective.

Last week my family and I went to a friend's house for a cookout. There were hamburgers fresh off the grill with tomatoes and onions and chips and dip, all topped off with plenty of conversation and laughter. As the evening drew to a close, we gathered around the fire.

It was better than the set of a Hallmark movie. The cows grazed in the distance, and the

chickens made their way to the chicken barn for the night. The wind rustled through the tall grass as the last rays of sunlight winked at us on the horizon. That's when we knew it was time to load up sticks with marshmallows and roast them over the fire.

When the marshmallows were perfectly, wonderfully burned, we covered them with pieces of chocolate and tucked them between graham crackers. I grabbed my burned marshmallow square and leaned back in my chair with my face to the night sky, wiping a bit of dripping chocolate from my face and tracing the Big Dipper with my finger.

And then I saw it.

The night sky was a symphony of twinkles. Layered behind the Big Dipper were thousands and thousands of stars. They sparkled and blinked and covered the night sky like the graham cracker crumbs falling from my s'more.

It was God's handiwork on display.

As I sat staring up at the sky with a mouth full of burned marshmallow and chocolate, I felt

the most incredible peace come over me. It was almost incomprehensible: the Maker of the stars, the Creator of the heavens, the one who made the sun rise in the east and set over the horizon of a green Kentucky pasture—he loved *me* more than I could ever understand.

He cares for me—and he cares for you, too. He watches over us and holds us close and tucks us into the small of his hand and protects us. He invites us to see him in the big things, like forgiveness and eternity. But he invites us to see him in the small things too, like the laughter of friends and the roar of a fire. We can see his handiwork everywhere—a reminder that he holds our future and all the days ahead.

Just like every twinkle in that starry sky.

Lord, thank you for showing me your majesty. Thank you for loving me. I rejoice that you are there in the big things and the little things. I love you. Amen.

We can see
his handiwork
everywhere—

a reminder that
he holds our
future and all
the days ahead.

The Masterpiece That Showed Up at My Front Door

We are the clay, you are the potter;
we are all the work of your hand.

ISAIAH 64:8

THE LAST TIME MY BROTHER MARK came to visit me, he brought a table. Some families show up for a visit and bring casseroles. Some families bring party supplies. Some families arrive with games and snacks and gifts. Our family?

We show up with furniture.

I'd asked Mark for a table for our living room, and he built one for me in his workshop. Like Joseph's coat, it was the table of many color scraps. It was crafted from leftover molding and

17

cut-off ends and wood pieces from all the shelves and boxes that had gone before. You could trace the history of all the projects in the lines of that tabletop. There were stories in each scrap—in every piece that had been collected from the floor of a woodworker's shop.

Mark brushed them off and sanded them down and cleaned them up and breathed new life into every scrap. Carefully, painstakingly, he knit those jagged, weary pieces from long-ago projects together.

At first glance, the pattern seemed random. To anyone but the creator, the pieces didn't make sense. But when they were placed all together, the pattern turned into a beautiful mosaic of memories. I'd asked him for a table, but instead? He created a work of art.

God is our master creator. He takes our brokenness and our pain. He takes our rough edges and our jagged pieces and all the times when life doesn't make sense. And he places them together into a beautiful mosaic. Isaiah 64:8 says, "We are the clay, you are the potter; we are all the work of your hand."

There may be days when you feel like you've landed on the floor of this world's workshop. You feel abandoned; you feel neglected; you feel overlooked. Maybe you even feel like your story is over. While everyone around you seems to be serving a purpose as a shelf or a box, you're in the leftover pile.

But God doesn't see things that way. He sees the potential in you when it's not obvious to everyone else. And he has a plan to redeem all those imperfect parts and create something even more beautiful than what was there before.

He's the master designer who rescues us from the workshop floor. He molds us and makes us according to his will. All our pieces are put together according to his good and beautiful plan.

He will never forget about us, because we are his masterpiece.

Lord, today I give you all the broken parts of me. I give you all the times when my life doesn't make sense. I place the pieces of my life in your hands. Amen.

Looking for Diamonds in All the Wrong Places

There is rejoicing in the presence of the angels of God over one sinner who repents.

LUKE 15:10

I'M STILL NOT REALLY SURE how I lost it.

One minute my diamond was sparkling in the ring on my hand, and then I blinked, and it was gone. The setting was there. The prongs were there. The band shone brightly. But the diamond? It was nowhere to be found.

I panicked. I tossed the pillows to the floor and looked under the sofa and checked the sink drain and pulled out the butter to see if I'd left a diamond behind when I was making popcorn.

There wasn't a sparkle to be found.

And then? Just when I thought all hope was lost, just when I thought I would be diamondless for the rest of my life, just when I thought I was going to have to fill those prongs with tinfoil, I saw something twinkling in the frayed tassels of the blanket.

What once was lost, now was found.

And so it was with the woman in the parable of the lost coin. I picture the scene this way: the woman tucked ten beautiful, sparkling coins into the back of a drawer in her tiny house, which overlooked the busy streets of the city. And then? In a moment, in an instant, she blinked. And only nine remained.

A coin was lost.

She was heartbroken. She pressed pause on her life and frantically began searching. She didn't scrub the kitchen counters. She didn't make the beds. She didn't chat with her friends at the well or wash her sandals or check to see if she had grain for dinner. She devoted her day to leaving no stone unturned. And then, just when

it seemed that all hope was lost, she uncovered the lost coin.

The village rang with the celebration. She gathered her friends and neighbors and told them of her good fortune. The streets were full of joy.

Her treasure had been found.

God seeks a treasure too, but his treasure is our hearts. We were lost and separated from him by sin, but when we open our hearts to him and accept his love, he welcomes us with open arms. All of heaven rejoices—and what a great celebration it is for the lost sinner who returns home!

We once were lost, but now—amazingly, wonderfully, incredibly—we are found.

Lord, thank you for welcoming me home. Thank you for loving me. Thank you for treasuring me as your child. Amen.

The Day the Stinky Socks Went Away

*I have learned the secret of being content
in any and every situation.*

PHILIPPIANS 4:12

I SPENT ALL SUMMER waiting for school to start again.

Every time I picked up a pair of flip-flops from the floor or washed a stack of dishes encrusted with dried-on Froot Loops or sorted through wet beach towels left in the back hall or gathered up stinky socks from every corner of the universe, I counted down the days. I wiped off the kitchen counters and tossed seven loads

of laundry into the dryer and waited patiently for the days of sparkling, clean floors and quiet. They couldn't arrive quickly enough.

The whirlwind of summer blew by. It was full of trips to the beach and afternoons at the pool and ice cream as the sun set and walks by the lake and basketball games and baseball games with extra innings.

And then one day it arrived.

The first day of school showed up bright and shiny in the middle of the second week of August. I packed everyone off with new back-packs and notebooks and sharpened pencils and wide-ruled paper and fancy new shoes.

My four kids left in a whirlwind amid hugs and smiles and laughter. I waved good-bye and then walked up the sidewalk and back into the house. I put away the breakfast dishes and checked the living room for stinky socks.

Then I sat down on the couch in the middle of the clean house with the sparkling floors and the sunlight dancing through the windows.

And in the silence, tears filled my eyes.

What? *Tears?* Wasn't this what I'd been longing for? Wasn't this what I wanted? I couldn't believe it.

I missed the messy.

How many times have we hoped and prayed fervently for some situation? How many times have we searched for a solution or an answer, only to discover that the very thing we longed for wasn't what we needed?

Philippians 4:12-13 says, "I have learned the secret of being content in any and every situation, whether well fed or hungry, whether living in plenty or in want. I can do all this through him who gives me strength." God wants us to be content. He doesn't want us to worry or be concerned—or to look for our own answers, on our own timeline. He simply wants us to trust him and recognize that he knows the when and the how and the why and the where.

And the location of every single stinky sock.

Lord, help me to understand that you are in charge.
Help me to be content with where you've placed me.
Help me to trust in you, believing that you
know what I need better than I do. Amen.

Perfect Imperfection

I praise you because I am fearfully and wonderfully made; your works are wonderful, I know that full well.

PSALM 139:14

I HAVE A PROJECT IN MY KITCHEN that belongs at the head of the popular table in the high school cafeteria. Odes have been written about it. Ballads have been sung about it, accompanied by flute and lyre.

This project that inspires wonder and awe?

It's my recipe wall.

It started out as a plate rack constructed from pine boards and molding that was attached to the wall. But something was missing. *It needs a little*

bling, I thought. *Why not a recipe?* I chose the cutest recipe I could find, with ingredients like salt and cinnamon and baking soda, and spelled out the words on the wall with gray vinyl letters.

The wall and its recipe became a conversation starter at our home. Visitors would comment on it. Neighbors would ask about it. Everyone wanted a recipe wall of their own. It was the talk of the county.

Until.

Until the day I noticed there was something odd about that wall. As I stared at it, something caught my eye. I tilted my head to the side, wrinkled my nose, blinked twice, and shook my head in dismay.

I couldn't believe it.

The recipe wall? The conversation starter? The most popular project in the western half of Kentucky? The one my children will talk about for generations to come?

It was totally crooked.

And not just a little off. It was off by major proportions. I forgot to use a level when I placed

the letters on the wall, which meant the lines of the recipe were crooked. And where the recipe lined up on the left, there was a two-inch difference between the top and the bottom. It looked like the leaning recipe of Pisa.

I can identify.

I'm a little crooked too. One of my eyebrows is higher than the other. My hair is unruly and back-talks me all the time. My nose crinkles when I laugh, and I have extraordinarily long toes and stubby fingers. There are days when I look around and discover I'm the shortest person in the room. Every time I look in the mirror, I see imperfection.

But God?

He loves me just as I am. He sees the beauty in me. He created me in his image, from the tip of my unruly hair and crooked eyebrows and crinkly nose to each and every stubby finger. The same is true for you, too. We are his children, and we are fearfully and wonderfully made.

Imperfect perfection—toes and recipe walls and all.

Lord, help me to love myself the way you do.
Help me to see the beauty you created.
Help me to embrace my flaws and recognize
the perfectness of your plan. Amen.

When the Struggle Is Real

Great is your love, reaching to the heavens;
your faithfulness reaches to the skies.

PSALM 57:10

WHEN YOU'RE IN THE MIDDLE of a struggle, have you noticed that everyone else already seems to have it all figured out?

I spent years trying to get pregnant, and when I looked around me, I felt like everyone else was about to give birth. Everywhere I went—every time I went to the store or ate a taco with extra onions— someone was talking about their ultrasound or their pregnancy cravings. I wanted to be happy for them. I wanted to celebrate on their behalf.

But inside? I wanted to scream.

Hannah could identify. We first learn of Hannah in the book of 1 Samuel. She was married to Elkanah, who had two wives. The ever-present struggle in Hannah's life was that Elkanah's other wife, Peninnah, had children and Hannah had none. The worst part was that Peninnah never let Hannah forget it. She taunted Hannah and constantly reminded her of her inadequacies in the childbearing department.

Hannah couldn't even. She sobbed and wept and stopped eating and sank into sadness. She wondered if her prayers would ever be answered.

And then?

One day Hannah and her family traveled to the Tabernacle. In anguish, Hannah fell to her knees. All the sorrow, all the reminders of her failure to conceive, and all the grief that was bottled up inside her came pouring out. She prayed with such devotion that her lips moved without words. She called on the Lord to give her a son, and the prayers came directly from her heart.

The Lord rewarded Hannah's faithfulness. He

heard the prayers of her heart and her fervent petitions. God answered, and she gave birth to a son named Samuel.

But what if Hannah's script had a different ending? What happens when, like Hannah, we face our own struggles and we pray, but those prayers go unanswered? What happens when we seek the desires of our hearts and our petitions seem to fall on deaf ears? What happens when the answer isn't the one we want to hear?

Scripture tells us that no matter the situation, no matter the struggle, no matter the challenge, there's one thing we can rely on: God's faithfulness to us. He is good. He is steadfast.

We serve a loving Father who lifts us up and gives us the strength to face the challenges ahead. Especially when the struggle is real.

*Lord, I give my struggles to you today.
I pray with my whole heart, asking you to
take away my bitterness and my sorrow.
I leave my burdens at your feet and
ask for peace and understanding. Amen.*

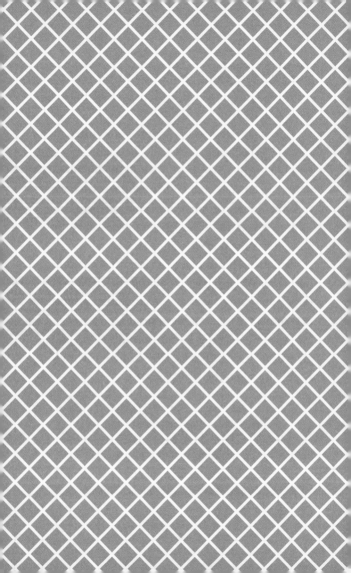

Hello, Goliath

*The seed on good soil stands for those with
a noble and good heart, who hear the word,
retain it, and by persevering produce a crop.*

LUKE 8:15

I'VE SPENT MOST OF MY MOM-LIFE watching baseball.

I've huddled underneath blankets, shivering and frozen, drinking hot chocolate while watching an enthusiastic first grader with missing front teeth play ball. I've sat in stands so hot you could fry an egg on them and sipped sweet tea to stay cool. I've worn T-shirts with the number 11 printed on the back to high school ball games and cheered until I couldn't hear my own voice.

I've sat in the car on long rides home after a loss and listened to the silent sadness of a tired baseball player covered in red clay and dirt.

Last week was our first game of the season. Our opponent was one of the biggest schools in the area, which meant that we were the underdog.

Hello, Goliath. Nice to meet you.

The game started as predicted. We were scoreless while they tallied up run after run. I looked up and prayed for rain.

And then?

Zack, wearing his number 11 jersey, stepped up to the plate. He stood there under the lights of the field with his wavy brown hair and a grin that would melt your heart. The pitcher threw toward home plate, and Zack brought his bat around, hit that pitch with all his might, and knocked the ball into yesterday.

If I squinted, I could almost see that first-grade ballplayer with the gap in his front teeth. All those years of watching. All those years of rain and cold and sun and shade and sweet tea.

All those baseball seeds that had been planted in the fields of long ago.

All for a moment like this.

Sometimes the harvest isn't for us. Sometimes we sow seeds, not knowing if they'll ever grow. Sometimes we invest time and energy into a situation or an individual and never see the fruit. Sometimes we water our seeds through the heat of the summer and the frozen days of winter, and we watch in vain for tiny shoots to spring up.

The truth is that sometimes we never see the seeds bloom. But that doesn't mean we stop planting. That doesn't mean we neglect the garden. Instead, we need to step out in faith and sow our crops even though we know we may never see them grow. We simply need to plant and water and nurture our seeds in the soil of today.

And trust in the God who's got tomorrow.

Lord, help me to plant seeds for you today and to water and nurture the crops I've planted. Help me to persevere, even when I don't see results. Amen.

The Day the World Raised Its Eyebrow at Me

Do not let your hearts be troubled.

JOHN 14:27

I'VE LIVED A LIFETIME of awkward moments.

Moments when I opened my mouth and inserted my foot. Moments I spent sinking a little into myself while the world looked at me and found me wanting.

Never was I more awkward than at my first blogging conference. I went all alone, with my red lipstick and sparkly flip-flops and a bucketful of anticipation. The conference started with a welcome party for all attendees on the first night.

I put on my new outfit and my dancing earrings and walked into a room filled with people I'd never met before.

Nervously clutching my business cards that I'd self-printed on Walmart paper, I casually strolled up to the first table of bloggers I saw and introduced myself. They looked me up and looked me down, shrugged dismissively in my direction, and glanced around for someone more popular with better hair. Right then and there, standing alone in the middle of the room with laughter and conversation swirling all around me, I shrank a little inside.

I turned and awkwardly made my way to another group of beautiful people in beautiful outfits who were laughing and talking and becoming instant best friends. The same story played itself out again. And again and again and again.

The world had raised its eyebrow at me and found me wanting.

The next day, I curled my hair and applied red lipstick and willed the sparkles on my flip-flops

to shine even brighter. The awkward started to fade, and I made some lifelong friendships over the course of that weekend as I learned to navigate this new world of blogging.

But if I'm truthful, I still think about that first night and shiver.

Have you ever had a moment when you felt less-than? Has there ever been a time when you felt the sand shift beneath you and you lost your way and your sense of worth? Have you ever allowed hurtful words or comments or looks to make you feel small?

It's easy to get caught up in the way the world looks at things and lose sight of how God views us. He treasures us as his children. Our incredible heavenly Father loves us with a love that's beyond human comprehension. He sees our awkwardness and our missteps and our failures, and he loves us anyway. And the best part?

There's nothing we can do to lose that love. Ever.

> *Lord, help me to remember that I have worth as your beloved daughter. You have made me in your image, and I am a child of the King. Thank you for loving me. Amen.*

Leaving It All on the Altar

Whatever you do, whether in word or deed,
do it all in the name of the Lord Jesus, giving
thanks to God the Father through him.

COLOSSIANS 3:17

WHEN WE WERE FIRST MARRIED and my husband was in school, we lived on love.

It was all we had. After I gave birth to our oldest child, Denton, my husband worked three jobs to support us. And even then, our ends just didn't ever seem to meet. We had almost nothing. We lived on noodles and sweet tea. We cut our own bangs. We had to save up our pennies just to shop at yard sales.

There was always too much month at the end of the money.

The widow in Mark 12 could identify with those circumstances. She barely had enough to support herself, and as a woman in her time, it wasn't like she could just fill out an application and get a job. One day she quietly entered the Temple courts and stood in line to make her offering to the treasury. Ahead of her, wealthy individuals tossed bags full of riches into the coffers.

And then it was her turn.

She walked up to the collection box with a humble spirit, extended her hand, and gently put in two small copper coins. The people gathered around probably rolled their eyes and laughed at her behind their hands. The rich and the wealthy may have glanced at their overflowing bags of money and scoffed at her meager offering.

But Jesus? To him, her offering was more precious than all the combined gifts of the rich Temple patrons. They gave only a small portion of what they had. Those wealthy individuals laid

down a part, not the whole. But the widow? Those two small copper coins were all she had. She gave everything. Her savings. Her livelihood. Her next meal.

She didn't give part of what she had. Instead, she left it all on the altar.

That's what God asks of us. He doesn't want just portions of our lives and our time and our resources. He doesn't want to be a part of our lives only on Sunday morning. He doesn't want us to give our best to the world and make time for him during the commercial breaks.

God wants our good *and* our bad. He wants every wrong turn and every victory. He wants every cloudy day and every ray of sunshine. He wants our laughter and our tears. In every situation. In every way. In everything.

He wants our all.

Lord, let me lay everything I have on the altar.
Help me to place you first today in
all I say and do. Amen.

God wants our good
and our bad.

He wants every wrong
turn and every victory.

He wants every cloudy
day and every ray
of sunshine.

He wants our all.

When You Think You're in Charge

*Many are the plans in a person's heart, but
it is the LORD's purpose that prevails.*

PROVERBS 19:21

I'M SCARED OF FLYING.

Not a little scared, as in I shiver slightly when I think of an airplane. No, I have a giant, terrifying, almost uncontrollable fear of being forty thousand feet in the air. This is the kind of fear that makes me shake from the top of my head to the tips of my toes. My family tries to reassure me. "God's in charge," they say. "Flying is safer than driving," they tell me.

I know.

I get it.

I'm smart like that.

Rationally I understand that flying is safer. I see the statistics. I read about the safety features. I've even googled how many people fly in a single day just to make myself feel better. But when I plan a trip, all I can think about is how safe I feel with the car on the ground and my hands behind the wheel.

So I drive.

Last spring I found myself in a circumstance where I had to fly. There was no getting around it—flying was my only choice. So I planned my trip carefully. I chose a flight in the middle of the day on an airline with a great safety record. I made sure to select a window seat so I could keep a watchful eye on the plane.

I spent two hours and fifty-four minutes staring at the airplane wing. I watched as the flaps went up and down. I checked the lights on the side of the plane. I made sure the wings were still attached. My eyes never left the window because I knew that if I was watching, if I was checking

on everything, it would be fine. If I was in charge, everything would be okay.

Even though I have absolutely no idea how to fly a plane.

Isn't that so often how we live our lives? We think we're in charge. We think if we're on the task, nothing bad will happen. We think we can protect ourselves and our families from the danger ahead because we're on top of every situation.

In reality, we're not even close.

God's ways are not our own. He has incredible, amazing plans for our lives, but we're so busy trying to fly our own plane that we forget to trust him. We lean on our own understanding instead of seeking his will.

He's a much better pilot. It's time we all turned over the captain's seat to him.

And stopped window-seat driving.

Lord, there are days when I want to be in charge. Help me to let go, give up my perceived control, and let you lead. Thank you for steering my plane. Amen.

The Day I Realized
My Mother Was Brilliant

When I was a child, I talked like a child,
I thought like a child, I reasoned like a child.
When I became a man,
I put the ways of childhood behind me.

1 CORINTHIANS 13:11

I'M STILL NOT SURE how it happened.

One day I was sitting at dinner and noticed that one of the twins was holding her fork in her fist. I stared at her for a moment, and then before I could help it, I opened my mouth, and this is what popped out: "I think it's time we started having fork-holding practice." *What? Fork-holding practice? Where did that come from? What made me say that?*

When did I start sounding exactly like my mother?

I can hear her voice swirling around and around in my head. I grew up on phrases like "Elbows off the table" and "If you can't say something nice, don't say anything at all" and "Leave your sister alone," and my personal favorite: "I don't really care what everyone else is doing."

Whenever she said things like this, me, myself, and my elbows would sigh and promise ourselves that when we grew up we would never talk like that or harp on manners or offer up completely unsolicited opinions. When we had children, we'd let them watch what they wanted to watch and talk how they wanted to talk and make decisions about what they wanted to do.

Then I grew up and had a family. My husband and I are now raising two sons and two daughters. And somewhere along the way, my mother's voice showed up. I tell my kids to keep their elbows off the table. I tell them not to argue with each other, and on more than one occasion, I may have offered unsolicited opinions.

In the middle of raising up my children, I discovered one of life's greatest truths: my mother had been brilliant all along.

Just as we recognize the sage advice of our parents as we grow older, we mature as believers too. As we grow in our faith, we discover insights into God's Word that we may have missed at first.

In 1 Corinthians 13:11, Paul says, "When I was a child, I talked like a child, I thought like a child, I reasoned like a child. When I became a man, I put the ways of childhood behind me." As we learn and grow and stretch our wings to new life in Christ, God opens our eyes to his plan for us. And he guides our every step.

I'm so thankful our heavenly Father is the most brilliant parent of all.

Lord, help me to grow in you.
Thank you for showing me the wisdom found
in your Word. Please walk beside me today
and surround me with your love. Amen.

The Original Supermodel

You should clothe yourselves instead
with the beauty that comes from within,
the unfading beauty of a gentle and
quiet spirit, which is so precious to God.

1 PETER 3:4, NLT

I ALWAYS WANTED to be a supermodel.

I wanted to be glamorous and toss my beautiful curly hair over my shoulder without a care in the world. I would glide when I walked and have naturally long eyelashes that flipped up at the ends and turned every head in the room.

Just like Esther.

Esther was the original supermodel. When King Xerxes sent Queen Vashti packing and appointed his commissioners to search the

country for the most beautiful women in all the land, he was looking for beauty beyond compare. Women were brought from every corner of the region to the king. He looked them up and down. And then?

He chose Esther.

But Esther had a secret. She was a Jew. During all those months of beauty treatments and all those weeks of primping and hair-curling and generally reclining on divans in the king's palace, Esther didn't mention her nationality to anyone. Her cousin Mordecai, worried for her safety, forbid her from doing so.

But then something terrible happened to threaten her people. A man named Haman became enraged at the Jews—specifically Mordecai—because they wouldn't bow down and worship him. So Haman plotted the destruction of Mordecai as well as all his people, the Jews, and convinced the king to go along with his plan. It was devious. It was diabolical.

It looked like all hope was lost.

As the forces gathered to destroy the Jews, our

supermodel, Esther, faced a choice. She could keep silent and save herself, or she could speak up and save her people. It was an overwhelming decision—one that could change the course of history.

Esther knew God had this.

She'd been graced with loveliness beyond compare. But more importantly, Esther had an inner beauty that eclipsed her outward appearance. She had conviction and strength and courage that shone brightly from within. She wrapped herself in the beauty of her faith and then threw herself on the king's mercy, begging for her people. The king heard her cries and granted her petition.

And God saved her people.

God has favored us, too. He has washed our sins clean. He has given us beauty and grace and inner loveliness beyond compare. He created us in his image and blessed us with courage and strength, and he instilled in us a faith that shines for all the world to see.

Just like a supermodel.

Lord, thank you for making me in your image. Help me to let my inner beauty shine so others may get a glimpse of who you are. Remind me to walk in grace today. Amen.

Picking Up the Pieces

You must all be quick to listen, slow to speak,
and slow to get angry. Human anger does not
produce the righteousness God desires.

JAMES 1:19-20, NLT

LAST WEEKEND I DISCOVERED half of a tabletop in the living room.

Someone threw a basketball across the room, and it knocked off the top of the antique wooden table. The tabletop broke and scattered into pieces all over the room. When I found the broken tabletop in the middle of the living room floor, I wish I could say I responded in love.

And if this were a Hallmark movie, that's exactly what I would have done.

But I forgot my Hallmark script that day. I didn't shrug it off. I didn't say it was okay. I didn't toss my hair and smile to myself at those basketball players' crazy antics. Instead?

I screamed.

It was a scream heard around the world. Other countries stood up and took notice. At the sound of all that righteous indignation, the inhabitants of the farmhouse came running and stood sheepishly in the middle of the room. Basketball players, cheerleaders, and four-legged friends stood staring at me, trying to ignore the elephant of that broken tabletop scattered across the floor.

I didn't say a word.

I just pointed, and they all squirmed. They looked at the ceiling and then at the floor and then at each other. Every now and then they'd tentatively glance at me to see if I was still pointing. Then, in the middle of the standoff, our golden retriever, Buddy, sighed, sank to the floor, and put his head on his paws. He shot the most dejected look in my direction.

And I couldn't help it: I burst out laughing.

I tried to be stern. I tried not to giggle. I tried to continue pointing. But right in the middle of the living room with pieces of broken table all around me, I laughed until I cried.

I laughed that time, but the entire table episode made me think: How many times have I reacted in anger when grace was required? How many times have I let my temper flare when a cooler head should have prevailed? James 1:19-20 instructs us to be slow to get angry, since our anger doesn't make us into the kinds of people God wants us to be. Instead of becoming angry at our sin, God has washed us clean and made us whole again. So when we choose grace instead of anger, we are acting like our heavenly Father.

Today, when we're faced with a broken tabletop or a rude reply, instead of choosing anger, let us choose grace.

Lord, thank you for forgiving me.
Let me follow your example and extend
grace instead of anger today. Amen.

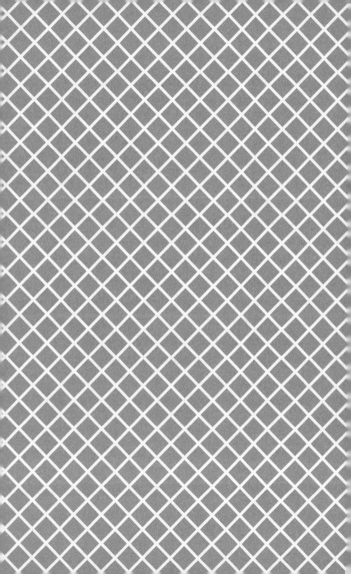

Watch Where You Step

The LORD makes firm the steps of
the one who delights in him.

PSALM 37:23-24

EVERY MORNING WHEN I WAKE UP, my house and I have a heart-to-heart. I go downstairs just as the sun is peeking its sleepy head around the corner and shining in through the vintage windowpanes. The house is quiet, and no one is downstairs yet to ask where the Fruity Pebbles are. This is one of my favorite parts of the day—just my house and me.

Yesterday I walked down the hallway and said hello to the pictures on the wall. Then I

walked through the butler's pantry and folded a dish towel. I pushed the tall basket against the wall and told the pantry it sparkled. In the living room, I fluffed two pillows, rearranged the chairs, and dusted off the table with my hand.

I saved the dining room for last. It's my favorite. In the morning, the sun comes shining through the windows, making the chandelier sparkle and the burlap curtains glow. I pulled a few dead leaves from the centerpiece and fixed the chairs.

The day was going to be amazing.

As I quietly, almost reverently, walked behind the dining chairs to open the curtains, suddenly, out of nowhere, I jumped. I leaped in the air as if someone had just announced over the loudspeaker at the dollar store that all the clearance items were now 90 percent off. But this time I didn't jump for a good reason. Grimacing, I looked down at the perfectly patterned rug. There, in the middle of a beautiful gray and white flower, I discovered that the dog had left me a present.

And it was oozing out between my toes.

Stepping out in faith can be a lot like my journey through my house that morning. There are moments of amazing. There are moments when you can feel God's presence in the sunlight as it streams in. There are moments of joy and awe and wonder as you see the plans God has for you unfold.

But then? Sometimes doubt creeps in. The journey gets rocky, and you question your purpose. You start to wonder about the path you're walking, and you lose your focus. You take your eyes off him.

But God never abandons us, even in those moments when it's hard to see how he's working. He wants us to trust in his Word and keep our gaze on him. He wants us to commit our paths to him, knowing that he will make our way straight.

Even when we take a misstep.

Lord, help me to commit my steps to you.
Help me to keep my eyes focused on you
and walk in your footsteps. Amen.

Step away from the Wheel

Come to me, all of you who are weary and carry heavy burdens, and I will give you rest.

MATTHEW 11:28, NLT

HAVE YOU EVER SEEN a hamster on a wheel?

It looks something like this. The hamster steps on the wheel. It starts to run, and the wheel starts to spin. The more the hamster runs, the faster the wheel spins. Faster and faster, and around and around and around. Except the little creature isn't actually going anywhere. It isn't any closer to its destination than when it started. In fact, the hamster would be much farther along if it would just press pause.

If it would just step off the wheel.

Martha from the Bible and that hamster have a lot in common. When we read about Martha in Luke 10:38-42, the first thing we discover about her is that she was busy. Extra busy with hustle and bustle layered on top.

One day Jesus stopped by to visit Martha and her sister, Mary. Martha was beside herself. She put on her apron and swept the dining area and laid out the best serving platters and ground up some grain and prepared the meal.

All without any help.

When she looked around for someone to help get the fruit platter ready and called out to her sister, all she heard was silence. No one answered. No one cared. No one worried about whether the chairs were brushed off or the bread had time to rise or the spiders were ushered out the door. Her sister was too busy sitting at the feet of Jesus.

And the worst part? No one noticed all of Martha's busy.

Martha was mad. Can you blame her? All

that hurry-up. All that prep. All that work. All. By. Herself.

So she did the logical thing. She complained to Jesus. She told him that she'd done all the work, and could her sister please press pause on the sitting and get up and help?

Instead of addressing Mary, however, Jesus gently chided Martha: "My dear Martha, you are worried and upset over all these details! There is only one thing worth being concerned about" (Luke 10:41-42, NLT).

Mary chose the unbusy. She chose to sit at the Lord's feet.

So many times we fill our lives with tasks that take us away from the Lord instead of drawing us in. So many times we run around on the hamster wheel of daily to-do tasks instead of sitting at the feet of Jesus. But life doesn't have to be like that.

Today, I encourage you to take a moment.

Breathe.

And unbusy your heart.

Lord, the enemy loves it when I am too busy for you. Help me to prioritize you in my life. Help me to step off the wheel and sit at your feet. Amen.

It Looked like the End of an Era

*If anyone is in Christ, the new creation has
come: The old has gone, the new is here!*

2 CORINTHIANS 5:17

THERE'S NO BETTER GIFT than turning something
a little old into something a little new.

When I was growing up, my father planted
a tree in our yard. It grew over the years until it
took over the driveway with its leafy branches. It
was one of those realities that was ever-present in
my life as I grew up (along with *Fantasy Island*,
Aqua Net hair spray, and sequin-pocket jeans).

My father loved that tree. He was so proud of
it. He watered it through hot, dry summers and

trimmed its leaves and watched it grow. I think the tree was his favorite place to work out all his problems. He'd have lengthy conversations with it—confidences shared from his heart to an old friend. I was never really sure what he whispered out there or what was on his heart.

But I know that the tree heard every single word.

I grew up, got married, left the house, and forgot about the tree. Until one day when my brother called to tell me the tree had been struck by lightning and had come crashing down. All those confidences. All those years of watering and caring and dreaming and nurturing—taken down in a single second. It was heartbreaking.

It looked like the end of an era.

Until later that year, on Christmas morning, when I found a package tucked under the Christmas tree with my name on it. Inside was a wooden bowl my brother had made for me. He had taken part of the trunk from the broken tree and painstakingly carved out the sides and shaped the center into a serving dish. The tree

had been reimagined and reshaped into a new creation.

What was once lost to me had been found.

What was once old had been made new.

The story of that tree reminds me a lot of my relationship with Christ. When I tumble down, he picks me up. When I'm struck by the lightning of a crisis, he heals my wounds. When it looks like it's all over for me, he gathers up my broken pieces, puts me back together, and offers me the gift of salvation and new life in him.

And just like that bowl, the gift tag has my name on it.

Lord, thank you for making me new again.
Thank you for healing my wounds.
Thank you for picking up the broken pieces
and making me whole. Amen.

Fields of Barley

Wherever you go, I will go; wherever you live,
I will live. Your people will be my people,
and your God will be my God.

RUTH 1:16, NLT

WHEN I WAS IN COLLEGE and I decided it was
time to find my future husband, I looked every-
where.

I hung out in the library because I figured
everyone there was smart. I sat for hours on a
park bench wearing a bow with my name on it
in case someone cute walked by. I went to get-
togethers and parties and book clubs and study
sessions, all in search of someone special.

If only I had pressed pause. If only I'd taken

a page from Ruth's book. I could have saved so much time by simply looking in the barley field.

Ruth grew up in Moab. She lived with her husband, Mahlon, and his family, including Naomi, Ruth's mother-in-law. Tragedy struck when Mahlon, his brother, and his father all passed away within a short period of time, leaving behind Naomi, Ruth, and Ruth's sister-in-law, Orpah. Soon after, Naomi told her daughters-in-law that she was heading back to her homeland. She released them from their obligation to her and told them they were free to remarry.

But Ruth didn't listen.

She told Naomi she loved her and that she loved Naomi's God and that she would follow Naomi wherever she went. So they packed their bags and headed to Bethlehem. Ruth and Naomi arrived in town at the beginning of the harvest. To provide food for them both, Ruth went out to the fields to glean. And in the middle of the barley field?

She discovered Boaz.

He was smart and handsome and kind, and he owned the very field she was gleaning in. Day after day she worked his fields, and when the harvest season was over, Naomi told her to go and lie at his feet. Ruth followed her instructions, and Boaz saw her loyalty. The next day he met with the elders, and the way was cleared for them to be married.

Ruth was obedient. Not just a little obedient. She won the blue ribbon in the obedience event. Time after time, Ruth stood at a crossroads. And every time, she chose the road of unglamorous obedience. She followed Naomi to a foreign land. She listened to Naomi's suggestion about which fields to glean in. She humbled herself and lay at Boaz's feet. She let Boaz address the complications that arose from their potential marriage.

God honors obedience. He wants us to give him control of our lives. He wants us to let him direct our paths with every step.

Even when it takes us through a waving field of barley.

Lord, help me to be obedient to you today. Direct my ways. When I face a crossroads, let me step back and let you lead. Amen.

On Markdown

Let him lead me to the banquet hall,
and let his banner over me be love.

SONG OF SONGS 2:4

I WAS ABOUT TO LEAVE the thrift store when I saw it.

It was standing in the corner with five different price tags—each slashed with a black line signifying markdown after markdown. It was a desk—or at least that's what it looked like it might have been in another furniture life. It had a broken leg and a drawer without a front and a top with nicks and scratches and dings.

And it wobbled whenever anyone came within a one-foot radius.

It was unloved and unwanted. Shopper after shopper had shrugged their shoulders and walked by the desk without a second glance. No one took time to look beneath the layers of paint and the missing door front and the leg that wasn't. No one had looked beyond the wobble.

Until I came along.

I took that five-times marked-down desk and brought it home with me. As I carried it into the house, I whispered to it that it was beautiful. I told it that it was loved and wanted and that I had amazing, incredible plans for it.

Then I cleaned it up and washed away the years of dirt and grime and neglect. I repaired the scratches and the nicks and the dings and found a leg that matched. I sanded and primed the surface, painted it a brilliant red, and glued cork squares on the desktop to cover the cracks.

The desk that no one had wanted was now restored.

I can relate to that desk on so many levels. There are days when I feel like I'm sitting in a corner with five markdown stickers on me. There

are days when I feel unloved and unwanted, and my dings and dents are on display for everyone to see.

But God's got me. His love for me never wavers. When I feel rejected, he covers me with his love. When I feel overlooked, he reminds me that he sees me. When I feel dirty and unwanted, he washes me clean. When I feel alone, he welcomes me to his banqueting table.

I once felt unworthy, but now? I know I'm a daughter of the King.

Even if sometimes I still wobble.

Lord, show me your favor today. Thank you for giving me a place at your table. Help me to put aside my feelings of unworthiness and remember that your banner over me is love. Amen.

Hold On Tight

*I cling to you; your right
hand upholds me.*

PSALM 63:8

HAVE YOU EVER NOTICED how fast time flies when you're not paying attention?

I remember when it took an eternity to get from the Fourth of July to Christmas. And now? One minute I'm under summer skies looking up at the fireworks, and then I blink and I'm decking the halls.

My twins, Westleigh and Whitney, and I spent last week school shopping for pens and folders and notebooks and spirals and Post-it

notes. It was fun. I like a polka-dotted locker shelf as much as the next person.

But here's the thing.

I'm not sure if I'm ready. Weren't the twins just hosting the entire stuffed animal kingdom at a tea party? Wasn't I just wiping noses and tucking tiny barrettes into blonde curls and packing lunches with fruit snacks?

I want to press the pause button and tell them to stop growing up. I want to grab time by the tail and tell it I need an extra minute to catch my breath and adjust. I want to go to one more tea party and ask a striped zebra if it has finished its homework.

All of those thoughts and a zillion more were running across my heart as I loaded the cartful of school supplies into the back of the car. I shut the door, turned on the air conditioner, and sat in the parking lot in silence for a moment.

I glanced at the twins piled into the car amid bags of pens and notebooks, and I reached for my phone to take a picture. I wanted to capture this here and this now so one day I could look at

the photo and remember the time when school shopping was a thing. As I held out my hand, one of the twins grabbed it.

Laughing, I squeezed her hand and said, "I was reaching for my phone."

"I know," she said. "But my hand is so much better."

That simple statement shook me to my core.

How many times does God whisper that to us? How many times is God holding out his hand to us and we reach for our phones instead? Time is speeding by. The days and months pass in a blink. How much better if we let go of the things of this world and hold on to God instead?

Here's my hand, Lord.

I'm holding on tight.

Lord, let me put aside the things of this world and focus on you. Thank you for holding out your hand to me. Help me to remember to hold tight to you and the promises of your Word. Amen.

Here's my hand, Lord.

I'm holding
on tight.

Joyfully Ever After

When anxiety was great within me,
your consolation brought me joy.

PSALM 94:19

ALL MY LIFE I've lived for a good happily-ever-after.

I can't help it. I'm always looking for the glass slipper and wondering if there's a prince around the next corner and trying to figure out if I can find some mice to help me with the housework. I read the last chapter of the book first to make sure I'm not disappointed. I watch the entire two hours of a movie even though I know how it will end in the first five minutes.

And I never met a "once upon a time" I didn't like.

But did you know that happiness is different from joy? We use the words interchangeably, but they actually have different connotations. Happiness is an emotion that's triggered by an event or a circumstance. Happiness is fleeting. Happiness is temporal. Its best friends are cheerfulness and gaiety and merriment.

But joy? Joy is internal. Joy comes from within. It's a state of being rather than a temporary emotion. Joy is connected to faith and the peace that comes from knowing God as our heavenly Father. While happiness is the result of interactions with others or with things, joy comes from our relationship with Jesus.

And the amazing thing about joy? It's the foundation that helps us through the rough roads ahead. Joy is there in the valley. Joy is there when life tosses us up and twists us around and when the road ahead is uncertain. When we're faced with a challenge, happiness heads for the door, leaving frustration and anger in its wake. But joy remains.

Joy is a buffer against the storm.

How do we find joy?

Psalm 94:19 says, "When anxiety was great within me, your consolation brought me joy." We find joy through reading and studying God's Word. We find joy as we grow in our relationship with him. We find joy when we lay our burdens at his feet. Our incredible, amazing heavenly Father wants to give us that kind of long-lasting joy. It's ours for the taking.

He wants us to grow closer to him and to rejoice in him, no matter the circumstances.

And to all live joyfully ever after.

Lord, please fill my heart with joy.
Help me to walk with you throughout the day.
Help me to grow closer to you and
love you more. Amen.

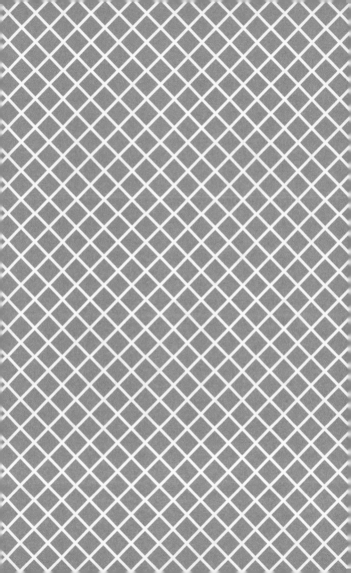

A Little Less Talk

*I can do all things through Christ
who strengthens me.*

PHILIPPIANS 4:13, NKJV

I HAVE A PHD IN TALKING.

When it comes to the art of conversation,
I'm a professional degree holder. I can't help it.
I have so much to say that I don't want to waste
a minute. I talk in the cash register line. I talk
to people in the aisles of the dollar store. I talk
to the assembled crowd at a yard sale about the
projects I'm going to make with the discarded
treasures. I talk about what I'm going to do and
how I'm going to do it and what it's going to look
like when I'm finished.

Except.

Except sometimes all that talking doesn't leave a lot of room for actual doing. I spend so much of my time talking about all of my amazing projects that I don't get around to actually working on anything.

I need a little less talk and a lot more action.

I could take lessons from the woman in Matthew 9. She suffered from a great sickness. It was painful and overwhelming. Her struggle was real. For twelve long years, she was in agony without any hope of relief.

And then one day she saw Jesus and the disciples strolling through town. *If I could only touch the edge of his cloak,* she told herself.

She knew the Lord was mighty. She knew the Lord was powerful. She knew that he healed the sick and the hurting. But she didn't waste time talking about her plan down at the local market. She didn't discuss it with fifty of her closest friends and neighbors. She didn't debate and make up a pros-and-cons list.

She simply put her faith into action.

She walked by Jesus, reached for the edge of his garment, and touched it for a moment. And a moment was all she needed. Jesus felt her touch and recognized her faith. He said to her, "Take heart, daughter . . . your faith has healed you" (Matthew 9:22).

And in that moment she was healed.

How many times have we talked about our faith instead of acting on it? How many times do we sit in the comfort of our own living rooms and discuss serving others and sharing our faith with others—someday. We think and plan and talk and attend Bible studies on putting our faith into action, but we never make the time to actually follow through.

I'm turning in my PhD in talking and stepping out in faith instead.

Lord, help me to live out my faith instead of simply talking about it. Help others to see your light through my actions. Help me to serve others and share your Word with them. Amen.

Every Step of the Way

*Tell it to your children, and
let your children tell it to their children,
and their children to the next generation.*

JOEL 1:3

AS I WAS GROWING UP, my father was my rock.

He was there for everything—for the good and the not-so-good. He was there all the times I wrecked the car or was late for my curfew or rolled my eyes or sighed or cut super awkward bangs in my hair or told him I wanted to work at Dairy Queen for the rest of my life. Every high and every low.

Every step of the way.

When I reached a goal or passed a test or

learned something new, he celebrated. When I stumbled or made a misstep or took a wrong turn, he was there to pick me up. His blue eyes would twinkle, and he'd smile at me like I was the most important person in the entire world.

But the most valuable lesson my father taught me? He taught me to love the Lord.

He showed me what real faith looks like by walking the walk every day. When he'd talk about a Scripture he just read or how he shared his faith with a stranger in the elevator between the first and sixth floors, his eyes would light up.

He was a pillar of faith, my role model in following the Lord.

And then one day when I was a young mom, my rock was gone.

Unexpectedly, without warning, he passed away while we were on a family vacation. I was devastated. It felt like the solid ground under my feet had just given way. I left the hospital early that morning and returned to the beach house where we were staying. Through a haze of tears, I sat down in a chair and stared out across the

ocean, so full of sorrow that I thought my heart would break into a million pieces.

Suddenly I felt a small hand on my arm. It was my ten-year-old son, Denton. He didn't say anything as he wiped the tears from his eyes and wrapped his fingers through mine. As I stared down at him, I knew. I understood. God was here—in this moment. I could feel his presence as he gently whispered to my heart.

It was my turn. My turn to help my children understand what it means to walk by faith. My turn to share my relationship with God with my family. My turn to pass on the lessons I'd learned.

That day as I walked in the footsteps of my father, I knew that God was with me.

Every step of the way.

Lord, help me to show the next generation your love. Use me to help them grow in faith. Help me to walk in faith every day. Amen.

❧Sometimes I Sag

*May the God of hope fill you with all joy and peace
as you trust in him, so that you may overflow
with hope by the power of the Holy Spirit.*

ROMANS 15:13

I'VE MADE A LOT OF decorating missteps in my life.

There have been so many poor curtain choices and wrong rug sizes and awkward kitchen cabinets I wish I could do over. So many unfortunate color choices I wish I could change. So many pieces of painted furniture I wish I could unpaint. But the worst mistake? The decorating *don't* I look at every day?

My attached couch cushions.

The struggle is real. Those cushions do not

come off. They are firmly, irrevocably, forever attached to the back of the couch. I can't fluff them. I can't pouf them. I can't plump them up. So, they sag—and not just a little.

Those cushions sag like the suntan-colored panty hose my mother used to make me wear when I was in seventh grade.

When you try to fluff the cushion, it stays for just a moment. Then when your back is turned or when someone sits on the couch to eat Cap'n Crunch or when an unnamed family member puts their stinky socks on the sofa, the cushions slump back into their sagging positions.

I thought the sagging was permanent. I thought the situation was hopeless.

Until.

Until a friend gave me a tip. There's a secret fix to all that slumping. The solution is something I never even knew was there. Underneath the cushion at the very back, behind the sag, is a zipper. And when I unzipped it, guess what I found?

Stuffing.

I took out the stuffing and poufed it and fluffed it and reworked it a little. Then I filled the cushion back up to the top with more stuffing. And now there's not a sag to be found.

I have saggy days too. Days when I feel like I'm lopsided. Days when I'm weary and worn and understuffed. And just like that couch cushion, I'm longing to be filled. Romans 15:13 says, "May the God of hope fill you with all joy and peace as you trust in him, so that you may overflow with hope by the power of the Holy Spirit."

Whatever you're up against, God's got you. His Word fixes all the lopsided in our lives. By his Spirit, we are filled. He makes us whole and fills up the corners of our hearts and lifts us up.

And makes our stuffing new again.

Lord, fill me with your Holy Spirit. Overflow my empty corners with joy and peace. Let your Word speak to my heart and make me new again. Amen.

By his Spirit, we are filled.
He makes us whole
and fills the corners
of our hearts and
lifts us up.

Saved by a Scarlet Cord

I trust in your unfailing love;
my heart rejoices in your salvation.

PSALM 13:5

I USUALLY HAVE A READY RESPONSE for situations.

I know what to do in the case of a tornado warning. I know what to do if I have a flat tire by the side of the road. I know exactly how to react if the power goes out in the farmhouse. But two random strangers showing up at my door and asking if they could hide under the stalks of flax on my roof?

I'd be at a loss.

Good thing Rahab seemed entirely prepared

for the situation at hand. Just before Joshua and his crew showed up to march around Jericho and bring the walls tumbling down, Rahab entered the scene. According to the book of Joshua, she hid the spies Joshua had sent to her city, and then she sent the king's men on a wild-goose chase, away from the Israelite spies.

After she saved the men, she asked for something in return. Rahab was an intelligent woman. She'd heard about God parting the Red Sea, and she recognized the strength of Joshua's God. As surely as she understood that flax provides excellent cover in times of trouble, she knew that God was going to deliver Jericho to the Israelites.

So she asked for mercy from the spies for herself and her family. The two men told her that she and her household would be safe, but only if she hung a scarlet cord from her window as a sign. Can you imagine the faith required to take a message like that to heart? Rahab hadn't been raised to follow God. She wasn't even a woman with a spotless reputation. She had almost everything to lose if she turned her back on her city.

But incredibly, she believed. She believed in what seemed virtually impossible. She understood the mighty power of God and believed in the victory and the salvation that he promised to those who followed him.

And she hung that scarlet cord as a sign of her faith.

Sure enough, God gave the Israelites the victory. They took the city, but Rahab and her family were kept safe. She trusted God with her whole heart. She believed in his promises, and she was saved.

Let's be like Rahab. Let's trust our impossible situations to God. Let's believe with our whole heart.

And let us, too, display our faith for the world to see.

Lord, let me rest in your unfailing love today. Help me to trust you enough to step out in faith when the situation seems impossible. Amen.

Pass It On

Let us love one another, for love comes from God.
Everyone who loves has been born
of God and knows God.

1 JOHN 4:7

YESTERDAY AFTERNOON I was standing in line at the store, smiling to myself.

I couldn't help it. I'd just discovered the best shade of red lipstick and a set of bobby pins with extra glitter and a new coffee flavor that smelled full of promise. The sun was shining and the birds were singing and the racks were full of new decorating magazines.

It was a good day to be in the checkout line.

After I paid for my purchases, I gathered the

bags and placed them in the cart. Humming to myself, I smiled again, so full of joy that I could feel my heart laughing. As I walked away, I caught the eye of a woman in the next lane over. She looked so sad—as if she were carrying the weight of the world on her shoulders.

I paused for a moment. She glanced away, and then she looked in my direction again, her weary gaze turned toward mine. As we exchanged glances, I wished with all my might that I could take away even a tiny bit of that weariness. So I did the only thing I could think of.

I smiled.

It wasn't much. Just a simple smile of encouragement. A smile of joy. A smile from my heart.

She didn't smile at first. She just stared blankly in my direction. Determined, I smiled even harder, willing her to smile back.

And then? I saw it.

A little glimpse of a grin. Slowly, almost as if it were taking on a life of its own, her grin grew bigger and bigger. I wanted to wink. I wanted to giggle. I wanted to tell the woman to pass on the

smile to someone else. Actually, I wanted to tell her about the sale on T-shirts in aisle seven. But I didn't say a thing.

I let my smile do all the talking.

As believers, we've been blessed beyond measure. We have been given grace and forgiveness and a peace that surpasses all understanding. We know that God's got us. He takes our burdens and our weariness and the worries of the day and gives us joy. He invites us to celebrate on the mountaintop and rejoice in the wonder of the everyday.

And when all that love bubbles over?

He wants us to pass it on.

Lord, thank you for showing me grace and forgiveness every day. Thank you for filling my life with joy. Help me to share that joy with others today. Amen.

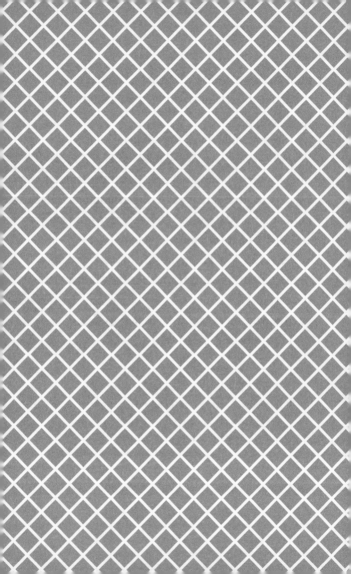

When the Mountain
Seems Unclimbable

*Put on the full armor of God, so
that when the day of evil comes,
you may be able to stand your ground,
and after you have done everything, to stand.*

EPHESIANS 6:13

HAVE YOU EVER CLIMBED a mountain?

When you stand at the bottom of a mountain and look up, it all seems so overwhelming. There are steep cliffs and crevices and so many vertical miles to go, and it seems like you can't find a foothold anywhere.

But the truth?

To climb a mountain, sometimes all you need to do is stand.

I've never climbed a literal mountain before.

But I do know what it's like to stand at the base of a problem that looks insurmountable. Not long ago, my daughter Whitney had eye surgery for a detached retina. One day she noticed that her vision was blurry with dark spots in the corners, so we rushed her to the doctor's office. They scheduled emergency eye surgery to repair it.

She was so brave. She didn't flinch. She grabbed my hand and held on tightly and stared up at me with big blue eyes that were full of courage and determination. The medical staff put a cap on her blonde curls and a patch over her eye, tucked her tightly into the hospital bed, and rolled her into surgery.

I stood there watching the doors close behind the cart, and then I dissolved into tears, grasping for understanding. *Why?* I sobbed. *Why? She is so small, and I'm so scared.*

I tried to pray, but I couldn't find the words. I was under attack from the enemy. I tried to lean on the Lord for patience and understanding, but my sorrow and fear got in the way. I tried to

search my heart for a Scripture so I could find comfort in the promises of God.

But the mountain was too high.

And then, ever so gradually, as I faced the overwhelming battle in front of me, I realized I wasn't fighting alone. Scripture tells us to put on the full armor of God. We are to buckle the belt of truth around our waists and take up the shield of faith and the helmet of salvation and the sword of the Spirit.

And then?

When we can't fight—when we're weary and we've lost our foothold on that mountain path— we are simply to stand. Stand against the schemes of the enemy. Stand firm on the Word of God. Stand on faith, with our feet ready.

And that's when it's time to let God do the rest.

Lord, I'm weary today. Help me to find a foothold in this mountain before me. Help me to stand on faith and place my trust in you. Amen.

Even Bible Superheroes
Have Flaws

It is by grace you have been saved, through faith—
and this is not from yourselves, it is the gift of
God—not by works, so that no one can boast.

EPHESIANS 2:8-9

WHEN I WAS A CHILD, it seemed as if the characters in my Bible lessons were superheroes.

There were Daniel and the lions' den; Noah and the Flood; Moses and the Ten Commandments; Abraham, the father of a mighty nation; Esther, who bravely approached the king; and Samson, who brought the temple house down. They were larger than life—each and every one. They served God in mighty ways. They were amazing. They were incredible.

It was all a little intimidating.

When I measured my life against these warriors of God, I felt so small. I've never gathered animals two by two or built an ark against all odds or received a promise in the form of a rainbow. I've never brought the house down with my oversized biceps. I've never faced down any lions—just a few growls in the center aisle of the 90-percent-off clearance section.

I don't feel mighty or strong—and certainly not perfect.

It wasn't until I got older and studied those Sunday school stories again that I discovered something I'd missed at first. Those superheroes? The ones who did amazing things for God? Those world changers?

They were imperfect too.

Scripture teaches that every one of God's warriors faced his or her own battle . . . and came up a little short. Moses got angry and struck the rock in frustration. Samson fell for the oldest trick in the book and gave in to temptation. Abraham

failed to place his trust in God and chose his own path, with some very unfortunate results.

And yet? God still loved them in the midst of their imperfectness.

More importantly, God uses the sins and weaknesses of each of these human beings to teach others. He uses their mistakes and their missteps to show us that he uses imperfect people. He knows we will mess up. He doesn't ask us to be perfect. There's nothing we can do—no ark-building, no temple-destroying, no work of our hands that will make him love us more. He meets us right where we are and embraces us as his own. He loves us despite every sin. Every stain. Every mistake. Every misstep.

Every imperfection.

Lord, thank you for teaching me through your Word. Thank you for your grace. Thank you for using my imperfection for your glory. Amen.

Filling the Empty Spaces

May you experience the love of Christ,
though it is too great to understand fully.
Then you will be made complete with all the
fullness of life and power that comes from God.

EPHESIANS 3:19, NLT

REMODELING A HISTORIC FARMHOUSE in the middle of the country is not for the faint of heart.

During our renovation of the one-hundred-year-old house we bought in Middle-of-Nowhere, Kentucky, we pulled down walls and replaced windows and added transoms and overhauled bathrooms from floor to ceiling. We removed wallpaper and added new sinks and painted every room in the house—some more than once. But

the project that was the hardest? The project that took names and showed us who was boss?

The kitchen floor.

It was the type of project that needed its own miniseries. There wasn't just one floor to pull up—there were four. We peeled away layer after layer of flooring until we finally discovered the beautiful original pine floors underneath. We made plans to stain the pine boards and recreate the finish that had been there when farmers ruled the farmhouse. Everything was ready. Everything was in place.

Except.

Except for the giant gap at the bottom of the baseboards.

The struggle was real. After we pulled up the layers of flooring, removing all that carpet and linoleum, we were left with a space between the baseboards and the new floor. There was a chasm the size of a small-scale Grand Canyon.

In other words, a giant hole remained where the flooring once was.

That visual illustrates our journey as believers.

When we accept Christ into our lives, we turn away from the things of this world. And when you take away the longing for sinful habits and patterns, it creates a hole in our lives.

Only God can fill up that hole.

He replaces our longing for the things of this world with a longing for him. Just as the hole in our baseboards was filled with molding, so our hearts are filled with the promises and sufficiency of God's Word. Our baseboards were made new with paint and caulk and primer; Jesus makes us new creatures in his sight through his transforming grace. He offers us his sin-cleansing love and hope for the future.

Enough to fill even the Grand Canyon.

Lord, fill me with your Spirit. Take away my longing for the things of this world. Make my heart new again, and help me to seek you more than anything else. Amen.

When Your Weeds Show Up in a Minivan

*If we confess our sins, he is faithful and
just and will forgive us our sins and
purify us from all unrighteousness.*

1 JOHN 1:9

LAST SUMMER was the year the weeds took over the farmhouse.

At first no one noticed. A little weed would pop up here, and another would pop up there. No one really worried about it. After all, they looked harmless. They seemed small and insignificant.

Until.

Until before we knew it, those weeds had multiplied and put down roots.

They partied like they owned the place and

planned fancy get-togethers and hosted Weeda-palooza and sold tickets in surrounding counties. Soon their weed relatives were showing up in minivans, along with lots of initiative and fortitude. Pretty soon they took over all the garden beds and told the flowers to take a hike.

It was so embarrassing.

From the road, you might have thought the weeds were part of the landscaping. They were so tall that they took on the appearance of plants and bushes and trees. The garden was losing the flower-bed battle, and the weeds were winning the war.

I tried to ignore it. I tried to act like the weeds weren't there. But after a while, I couldn't. They were a force of nature.

Literally.

I would walk by the flower beds on my way to the car and sigh longingly. If only my flowers would bloom again. If only I had more time to weed. If only I'd taken a weed-pulling class in college. If only my gardens looked like the perfectly manicured works of art I saw in glossy magazines.

You know.

The ones without the weeds.

A weed in the garden is a lot like sin. It starts small. A bad decision here. A wrong turn there. We think the sin is harmless. We think it's tiny and insignificant. We tell ourselves that we'll turn away from it tomorrow and that it's not such a big deal. We don't have time to worry about it today.

And then?

Just like the weeds in our flower beds, sin begins to take over our lives. That's why God instructs us to be vigilant against letting sin enter in. He wants us to rely on his promises and spend time in his Word to prevent sin from gaining a foothold. He teaches us to reach down and pull out even the smallest of sins before they have a chance to take root.

And before they invite their relatives over in a minivan.

Lord, help me to turn away from sin today.
Help me to pull out the weeds before they take root.
Thank you for your good plan for my life. Amen.

Standing on
the Promises

Show me your ways, LORD, teach me your paths.
Guide me in your truth and teach me, for you are
God my Savior, and my hope is in you all day long.

PSALM 25:4-5

LIFE HAS MORE CHOICES than all the grains of
sand in a desert filled with wandering Israelites.
Sometimes those decisions are easy, like whether
or not lip liner is needed for a night out on the
town. But sometimes the choices we make have
difficult consequences.

Have you ever been in a situation where you had
to stand up for what was right? You knew what you
should do. You understood the best choice to make
under the circumstances. But actually doing it?

That's the hardest part.

Just ask Zelophehad's daughters. They took a stand that changed history. We're introduced to Mahlah, Noah, Hoglah, Milkah, and Tirzah in Numbers. There they were, standing on the banks of the Promised Land after the Israelites had spent years eating manna and wandering through the desert. Their father had passed away in the wilderness, leaving behind his five daughters.

The problem?

They were women. And Zelophehad didn't have any sons. Without a male to receive his inheritance, all his property would be lost. His daughters wouldn't receive anything. They'd be adrift in the Promised Land, without a penny to their name.

What's a daughter to do?

If they stood up for what they thought was right, they might be ostracized. If they pleaded their case in front of the assembly, they might be ridiculed. Wouldn't it be safer to sit on their words? Wouldn't it be wiser to just accept their situation instead of rowing upstream?

But instead of settling for safe, Zelophehad's daughters grabbed their paddles.

They stood up and presented their case to Moses and other assorted important people. Moses listened and presented their case to God. God heard their pleas and granted their request. He said they should inherit the property.

The victory was won.

Stepping out on faith and making the hard choice to do the right thing is never easy. It's so much harder than it looks—especially when an entire nation is watching. But here's the thing: even when the situation looks hopeless, even when making the right choice looks hard with extra challenge on top, God's got you. He understands. He provides, and he paves the way for protection. And just like Moses did for Zelophehad's daughters, he hears our pleas and guides our choices.

Even when we're paddling upstream.

Lord, when I'm faced with a challenging decision, help me to make the right choice. Give me wisdom and discernment. Watch over me and guide my steps. Amen.

But here's the thing:
even when the situation
looks hopeless, even
when making the right
choice looks hard with
extra challenge on top,

God's got you.

When Your Reflection Comes Up Pumpkins

*Whatever is true, whatever is noble, whatever
is right, whatever is pure, whatever is lovely,
whatever is admirable—if anything is excellent
or praiseworthy—think about such things.*

PHILIPPIANS 4:8

I'M NEVER GOING TO BE on the cover of
Photographers R Us.

I'm not a professional photographer. Not
even close. I just make it up as I go along. I turn
a dial on the camera this way and twist a knob
that way and flip the screen over and squint at the
image and cross my fingers and hope for the best.
And sometimes it's so amazing it would make
your head spin. And other times?

It's so close.

Recently I was taking pictures of one of the rooms in my house for my blog. It was spring, so I filled vases with flowers and decorated the mantel with milk glass and tucked stacks and stacks of the most beautiful linens into baskets.

I couldn't wait to see the pictures.

I plugged the SD card into the computer and sat down at the desk as the pictures popped up on the screen. Everything was perfect. The flowers looked so crisp you could smell them through the screen. The linens were so perfectly in focus you could see the extra starch. The room looked fresh and inviting, with extra spring sprinkled on top.

And then I noticed something that made my photography-heart drop. There, in the reflection of the mirror, shining like an orange beacon on the waves of the ocean, were pumpkins.

And it was spring.

Somehow I hadn't seen the leftover fall decor when I was taking the pictures. I was so focused on the crisp linens and the vases full of flowers that I missed what the mirror was reflecting.

How often do our own life snapshots reflect

something other than what we hoped for? How often do we miss what we thought we'd tucked away from the world's eyes? How often do we overlook the remnants of a situation or a conversation that we thought we'd gotten rid of?

Our mirrors should reflect God's glory.

According to the book of Philippians, our life snapshots should be filled with "whatever is noble, whatever is right, whatever is pure, whatever is lovely." When we put our faith in God and trust him in every situation, he will daily renew our spirits, and his love will shine through us to others.

Even if sometimes our reflection comes up pumpkins.

Lord, thank you for loving me in all my weakness. Let my life be a reflection of you, and let others see your faithfulness in me. Amen.

Don't Cry over Spilled Paint

The LORD your God is with you,
the Mighty Warrior who saves.
He will take great delight in you.

ZEPHANIAH 3:17

LAST WEEK the unthinkable happened.

A do-it-yourself project came along that put me in my DIY place. We had a new door installed in the back of the house that showed up paintless. I planned for weeks to paint it, but other things kept coming up.

Until.

Until one day I couldn't take it anymore. I decided the door needed to be painted at that exact moment.

Right then and there, in my pajamas and robe.

I found a can of black paint in the workshop, put down a drop cloth, found a brush, taped off the doorknobs, and got started. The first brush of paint looked amazing. I smiled and mentally patted myself and my pajamas on the back. Pausing, I stepped back to admire my work. But somewhere in the stepping, my foot got caught up in the robe tie. I tripped, stumbled backward, and tipped over the open can of paint.

Time stood still. In slow motion, I watched as the entire can of paint poured onto the floor in a paint tsunami.

"Helllllllllllp!" I begged my pajamas.

I stared at the quickly spreading paint. I stared at the splatters now covering the walls. I gaped at the floor and the ceiling and the molding and the hallway and my ruined sleeves and my paint-splotched ties and made an executive decision.

My robe had to take one for the team.

I tossed the robe into the center of the paint blob and used the terry cloth to soak up the paint. It stopped the tsunami, leaving a thin layer of manageable paint to clean up. I spent the next

hour or so mopping and scrubbing and cleaning until the floor shone and the only drops of paint were on my brush.

At the time, the humor of the situation was completely lost on me. But now? I laugh out loud when I think of the robe that was there for me in my hour of need. Life is full of imperfect, silly, comical (at least in retrospect) moments like these.

God's got us—in every situation, every drop of spilled paint. He laughs with us. He delights in us and lifts us up and showers us with his goodness. He renews us with his overwhelming love and shouts with joy over every victory, no matter how small. God never fails us.

And in your hour of need, he is so much better than anything else.

Even a terry cloth robe.

Lord, thank you for the reminder that there is joy even in spilled paint. Help me to remember that you are there for me in all circumstances. Thank you, Father, for your unfailing faithfulness. Amen.

The Eighty-Four-Year Answer

*Those who hope in the LORD will renew
their strength. They will soar on wings like
eagles; they will run and not grow weary,
they will walk and not be faint.*

ISAIAH 40:31

I CAN'T STAND TO WAIT. Not even a little. If I'm standing in a long line or listening for a phone call or watching chocolate chip cookies bake and I have to wait more than five seconds, I start to twitch. My leg shakes, and I tap my fingers impatiently, and I roll my eyes, and I twirl and untwirl my hair until it has split ends.

Every waiting minute feels like an eternity.

Anna might have understood, because she waited too. We read about her in Luke 2. She

was the daughter of Penuel of the tribe of Asher, and she spent eighty-four years of her life waiting to see Jesus. After her husband's death, Anna lived all her days in the Temple. She never left to purchase new sandals at the market or hang out with her friends and eat figs and watch the entertainment at the local amphitheater. Every morning she woke up in the Temple, and every night when she closed her eyes, the last thing she saw was the Temple wall. She spent days and months and decades watching and waiting.

Waiting on the Lord.

But the most amazing thing about Anna? She didn't wait with impatience. She didn't roll her eyes and twitch her leg and twirl her head scarf. Anna didn't waste a single minute of those eighty-four years. She worshiped day and night, praising the Lord with fasting and prayer.

Anna embraced the waiting.

And then one day she was rewarded for her faithfulness. Mary and Joseph and their newborn son arrived at the Temple. Anna immediately recognized that this was the Messiah she'd been

waiting for. And in that moment she'd waited for all those years, she didn't complain. She didn't talk about the long wait. She didn't scold or twitch or roll her eyes over the fact that Jesus' arrival had taken so long.

She simply praised God for his answer.

Anna's example is imprinted on my heart. How many times have I cried out with impatience? How many times have I asked God for an answer to a situation that wasn't yet resolved? How many times have I complained that the waiting never seems to end instead of praising God for his steadfast love and faithfulness?

There is beauty in the waiting. Whatever we're waiting for, let's learn to wait like Anna. With great joy.

Lord, thank you for your goodness to me. I praise you for my prayers that are yet unanswered. Let me lean into you and wait with grace. Amen.

Lessons from an Ice Stormapalooza

Come near to God and he will come near to you.

JAMES 4:8

I HEARD IT BEFORE I SAW IT.

It was an ice stormapalooza. As water froze on the branches, the weight of the ice caused the branches to break, creating a never-ending cacophony of crackling and snapping and breaking as branches and trees all across the countryside came tumbling down. The wind ripped through the area, resulting in countless downed power lines. It sounded like the world was coming to an end.

The aftermath of the stormapalooza was overwhelming. The entire area was without power for days. Without electricity, the gas pumps stopped working and the water treatment plant shut down and local businesses were forced to temporarily close their doors.

Life as we knew it stopped.

We spent seventeen days without electricity, eating the entire contents of our pantry, playing Scrabble, making snow angels, braiding our hair, and wearing super-fashionable outfits with five layers of clothing. At first it was an adjustment. At first it wasn't easy. You don't realize how much you miss electricity until it's not there.

But in the middle of all those electricity-free days, something amazing happened.

Without cell phones or television or lights that turn on with a switch, we focused on faith and family and living life together. We invented new food combinations and tried to cartwheel down the hallway and handed out blue ribbons for the perfect snow ice cream recipe. Without dishwashers or laptops or computers, we actually

talked to each other. We told jokes and sang songs and played games and discovered conversation again.

Without all the busy, it was easy to concentrate on the really important. By the time the electricity came on, I was surprised to find a little sadness mixed in with my relief.

We live in a world full of distractions. So often we get caught up in the little things and forget to focus on God. We put off quiet time or lifting others up in prayer because it always seems like there are more things just around the next corner.

The truth? Nothing is more important than God.

Psalm 119:147 says, "I rise early, before the sun is up; I cry out for help and put my hope in your words" (NLT). We should seek his will every day. We should put those less important things aside to spend time in his Word.

All these years later, I'm so thankful for that ice stormapalooza, because it helped remind me to put down the busy and focus on him.

Lord, help me to put aside the busy. Help me to remove the distractions that are pulling me away from you. Help me to prioritize you in my life. Amen.

Let Your Light Burn Brightly

Be dressed ready for service and
keep your lamps burning.

LUKE 12:35

THE OTHER DAY I sat in a stinky gym on a hard, wooden bleacher watching a basketball game. As the roars of the crowd swirled around me, I glanced over at the bench where my son Zack sat patiently waiting for a chance to play. We had been here so many times before. Game after game, I watched as he sat on the bench and waited, hoping against all hope that today would be the day.

The day his turn would come.

He was ready. His eyes never left the court. His hands clenched and unclenched again. His left foot twitched as if it were already in the game, leaping after the ball. The first quarter finished. Then the second.

And still he sat.

My heart ached for him as he sat there, so still and silent, with his head held high. I wanted to run down and tell the coach how amazing Zack was—how many hours he'd practiced and how hard he'd worked.

Suddenly, out of the corner of my eye, I saw the coach wave him in. I sat motionless, almost afraid to breathe as I watched him run onto the floor. He was a blur on the court. He dribbled and passed, and then he got the ball back and dribbled some more. Then he lifted his hands and tossed the ball into the air toward the basket.

Time stood still.

For just a moment, the ball hung suspended in the air. Then, with the laser-like precision of a DIYer looking for yard sale signs, it swooshed through the net. The crowd went wild. I yelled

and jumped and waved my hands and cheered as loudly as I could.

In that moment, something happened that I'll never forget. Something that I'll tuck into the recesses of my heart for eternity. As the team headed back down the court, my son stood for a moment and scanned the crowd until his eyes met mine. And then? He laughed out loud, and his face lit up with victory.

And the smile of a champion.

Like that ever-watchful basketball player of mine, we are called to be prepared too. Like the wise bridesmaids in Matthew 25 who kept their oil lamps lit, Christ asks us to be ever vigilant and ever alert. We are to keep our lights burning brightly and our hearts prepared. That way when the time comes—when the groom arrives and invites us to the wedding feast—we will be ready.

Lord, please help me to be vigilant today.
Help me to prepare my heart for you.
Help me to keep my lamp burning brightly. Amen.

Waiting to Be Asked

I remain confident of this: I will see the
goodness of the L<small>ORD</small> in the land of the
living. Wait for the L<small>ORD</small>; be strong and
take heart and wait for the L<small>ORD</small>.

PSALM 27:13-14

WHEN I WAS A JUNIOR IN HIGH SCHOOL, I didn't get asked to the homecoming dance.

I was ready. I even had the most amazing outfit for the event. I glued my initials in glitter on the rear pocket of my jeans and sewed tiny plaid bows to the neck of my sweater vest and wrote my name on my ruffled socks in paint pen. I had the Aqua Net ready. I had the powder-blue eye shadow open. I had the red lipstick uncapped. Everything was set.

And then?

My outfit and I sat by the phone and waited for someone to call me.

But no one did.

If anyone in Genesis could understand my predicament, it was Leah. She waited too. She knew what it was like to be overlooked. She knew what it was like to have everyone else be asked except her.

One day, as she wandered the hills and dales of the countryside watching over her father's flock, she saw Jacob watching her sister, Rachel, across the field. It was love at first sheepshearing.

Jacob wanted to marry Rachel, but their father, Laban, told Jacob he had to earn the right for her hand with seven years of labor. Jacob agreed. And Leah? She was the one who wasn't asked. She was the one who felt unloved. She was the one who was unchosen.

Eventually Jacob ended up marrying both sisters, but that didn't change the fact that Rachel was still Jacob's first love. Once again, Leah wasn't first.

But her story wasn't over.

Jacob may not have loved her or chosen her, but God did. He hadn't forgotten her. Genesis 29:31 says, "When the LORD saw that Leah was unloved, he enabled her to have children" (NLT). One of her children was Judah, who was an ancestor of the Messiah. That's right—Jesus' line came through a woman who once felt unloved and unchosen.

God heard Leah's petitions and answered her prayers. And all the while? He had his hand on her. He had been laying the foundation for her life and preparing her heart for her role in his Kingdom.

Every single minute she was waiting by the phone.

Lord, when I'm feeling rejected or unloved, help me to remember that you have chosen me and that your opinion of me is what matters most. Let me wait with faithfulness. Help me to place my trust in you. Amen.

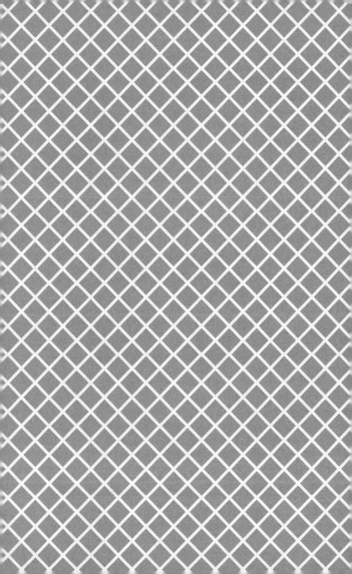

Let Your Cartwheel Scuff Shine

Purify me from my sins, and I will be clean;
wash me, and I will be whiter than snow.

PSALM 51:7, NLT

IF YOU WALK THROUGH our front door and turn left, there's a long hallway. A hallway with doors and moldings and a runner and glittering chandeliers. Most of the time the hallway is used for walking—the kind of walking that takes you from the laundry room to the guest bedroom and back again. But I recently discovered that walking is overrated.

At least for hallways.

Last week the hallway was transformed into a

training ground for the next gold medal gymnastics champions in cartwheeling. Two future stars decided that the hallway was the perfect place to practice.

So they back-bended and round-offed and one-hand cartwheeled their way down the long, narrow space.

And then?

I heard it before I saw it. Just like the London Bridge, that one-hand cartwheel came crashing down. It sounded terrible and loud. There was a lot of loud with extra noise on top.

I ran into the hallway to see a cartwheeler giggling on the floor next to her gymnastics partner, pointing at a giant scuff mark on the wall. Her tennis shoe had fought with the wall, and the wall had won. As I stared at the scene, I was torn between relief that my daughter was smiling and unhurt, and irritation that I had a mark the size of a small island in the Pacific on my wall.

Relief won out as I smiled at my daughters. Then I looked at the scuff again and sighed. How many times have I started out with a cartwheel

in my life and ended up with a scuff of my own? How many times have I tried something new and failed? How many times have I started out on a journey but stopped at the first challenge I faced?

Sometimes I wonder if I'm simply making the same mistake over and over. I keep trying but never move forward; instead, my wheels churn around and around in the mud. I lose traction. I lose momentum. I lose hope.

But here's the thing. Here's the wonderful, undeniable, amazing truth that's shown to us again and again in Scripture: God's got you.

Through every wrong turn. Every mistake. Every failure. Every one erased. Every scuff washed clean.

Now if only I could get that wall clean too.

*Lord, thank you for your forgiveness and grace.
Thank you for making my scuffs as white as snow.
Thank you for washing me clean and making
all things new again. Amen.*

I'm Looking at You, Hollywood

Shout for joy to the LORD, all the earth.
Worship the LORD with gladness;
come before him with joyful songs.

PSALM 100:1-2

WHEN I WAS A KID, I knew I was destined for Hollywood. I knew that somewhere, somehow, I would be discovered. One day an agent would hear my beautiful voice tinkling across the room and whisk me away to the bright lights of the big stage.

It was only a matter of time.

I practiced for hours in the back of our family station wagon. I'd hold a pretend mike, lean

against those blue vinyl seats, and serenade my brothers and sisters.

At the risk of stating the obvious, I was amazing.

The summer I was twelve, I finally saw my opportunity. My family attended a country jamboree in the middle of Arkansas. The band paused from picking and grinning and banjo playing and asked for volunteer singers from the audience.

"Me! Pick me!" I shouted, frantically waving my hand.

I knew this was my moment to shine. I stepped onstage and asked them to play "The Yellow Rose of Texas."

And then I started to sing.

I belted out the lyrics as loudly as I could. I closed my eyes and sang with all my heart, and eight key changes and ninety-seven off-key notes later, I opened my eyes to silence.

The band had stopped playing.

The audience was staring at me, stunned. No one said a word. At this point, some singers

might have been devastated. Some singers might have hung their heads and slunk off the stage.

Me? I was ecstatic. I thought it was wonderful. Standing there listening to the hush of the crowd, I was full of joy. My only thought was, *I must be incredible.*

After all, I'd left them speechless.

The Lord wants us to worship him with that kind of confidence. Psalm 100:4 tells us to "enter his gates with thanksgiving and his courts with praise." He wants us to lift our voices with abandon and make a joyful noise to him.

God doesn't care what the tune sounds like. We can sing with confidence, because he doesn't ask for perfect pitch or four-part harmony. He only asks that we lay our hearts and our voices at his feet and let him transform every off-key note into the sound of joy.

Lord, help me to lift my voice in praise to you today. Let the meditations of my heart be music to you. Let me sing of your goodness to me. Amen.

Knock, Knock.
Who's There?

*Here I am! I stand at the
door and knock.*

REVELATION 3:20

I STILL REMEMBER THE WONDER I felt on the day
the doctors and nurses told us our tiny prema-
ture twins were finally coming home from the
hospital. Joy filled my heart. I was so excited that
I shouted the news to anyone within a two-aisle
radius of the produce section at Walmart. Then
I ran home, called my husband, hopped into the
car, and drove away in a rush.

Leaving behind my diaper bag packed with
everything I needed to bring them home from
the hospital.

Sometimes when the most amazing, wonderful, incredible thing happens, we get so caught up in the excitement of the moment that we overlook the obvious.

Just like Rhoda.

Rhoda was a servant in the home of Mary, the mother of John Mark. One evening when she was no doubt in the midst of cleaning and scrubbing and preparing a snack of grapes and figs, she heard a knock at the door. She asked who it was, and the voice on the other side of the door proclaimed that he was the disciple Peter, who had recently escaped from prison.

What? Peter? Here at this house? She couldn't believe her ears. She thought she must be dreaming. She put down the grapes and ran to tell everyone that a miracle had happened.

Except.

Except that in the joyful haze and overwhelming emotion of the moment, she forgot to let Peter in. As she shared the news with everyone else, she left him standing outside. She heard his voice and didn't think to lift the latch.

Our friend Rhoda never opened the door.

If we're honest, there's a little Rhoda in all of us. How often have we prayed for an answer or sought specific direction in our lives and then, when the Savior knocks at the door in response to our prayers, we forget to open up and let him in.

God has a plan and a direction for our lives. He wants us to heed his voice and seek his guidance in all things. He wants us to commit our ways and our paths to him. And when he knocks?

He wants us to answer.

Lord, help me to seek you in all things. Help me to walk in your will and listen for your whisper to my heart. Remind me to answer when you knock. Amen.

The Siren Call of the Makeup Aisle

He has made everything
beautiful in its time.

ECCLESIASTES 3:11

WHEN IT COMES TO MAKEUP, my hope is always springing eternal.

I can't help it. I discover a new product in the makeup aisle, and my heart beats a little faster because I know this is the one. This is the product that will make my lashes a little longer or my cheeks a little brighter or my under-eye circles disappear in a flash. I buy it and bring it home and apply it . . . only to realize that nothing really changed after all.

I still look exactly like me.

I tell myself to stop this cycle. I tell myself to end the quest, and I listen—for a season. I valiantly

turn my cart away from the makeup aisle and buy something useful like hand soap instead.

And then?

I fall off the wagon.

One day I saw the most beautiful, sparkling bronzer you've ever seen. It glowed at me from across the store. I had to have it. I had to glow. So I gathered my pennies and left my no-makeup promises in the dust and ran to the checkout counter.

As soon as I got home, I ripped open the package and patted bronzer on my face. I stared at the mirror. No glowing yet. I applied some more, glanced at my reflection again, and applied one last coat for good measure.

Now?

I was bronzer-amazing.

I left the house skipping and went out to eat with friends. All through the meal, I smiled to myself. Finally, I'd found the perfect makeup product. I floated through that evening on a haze of makeup confidence. When I arrived home later that night and went to take off the bronzer, I almost screamed out loud.

I was orange and glowing like a well-done piece of sweet potato.

Why do we search endlessly for beauty in the makeup aisle? Why do we either shy away from or obsess over our reflection in the mirror? Why do we look high and low for the product that will make us feel better about ourselves?

We are already perfect in God's eyes.

True transformation comes from within. God fills us up with his love and gives us beauty that's beyond compare. Numbers 6:24-25 offers this beautiful benediction: "The LORD bless you and keep you; the LORD make his face shine on you and be gracious to you." God's radiance shines brighter in us than any bronzer ever could.

Inner beauty: it's so much better than glowing like a vegetable.

Lord, help me to seek lasting beauty. Help me to work on making my insides glow. Today, help me to love myself a little more, knowing I'm made in your image. Amen.

We are
already
perfect

in God's eyes.

When the Cookie
Crumbles

As the heavens are higher than the earth,
so are my ways higher than your ways and
my thoughts than your thoughts.

ISAIAH 55:9

I COULD WRITE A BOOK on Pinterest fails.

You know. Where you follow the instructions to the letter, but somehow, somewhere, somewhy it doesn't turn out like the picture.

The other day I saw the most amazing idea for cookie cups on Pinterest. You turn over a muffin pan and place the refrigerated cookie dough on the back side of the pan. Then you bake it and flip it over again, shake the pan a little, and these adorable cookie cups pop off.

Brilliant, right?

Everyone I talked to about the idea totally agreed with me. They knew it would work. They'd heard that someone's sister's great-aunt's cousin twice removed had made the cookie cups and they turned out perfectly.

I had to make them.

I followed every step of the recipe. I sprayed the back of the muffin pan with cooking spray, cut circles out of the cookie dough, pressed them onto the back of the pan, and baked them according to the directions.

I didn't miss a step.

Then I sat back and waited as the kitchen started to smell absolutely delicious. I couldn't wait to see my cookie cups. Finally the timer went off, and I opened the door to the oven.

Inside it looked like a scene from a horror movie.

Pieces of cookie dough were everywhere— spilling over the top of the pan and dripping off the edges and onto the bottom of the oven. *What?* What was this? How could this be? I'd followed

the steps. I hadn't missed a single instruction. This certainly wasn't what the Pinterest picture looked like.

Not even close.

How many times have we followed the formula? How many times have we gone all Pharisee and followed the law to the letter? How many times have we dotted every *i* and crossed every *t*, and still things didn't turn out the way we hoped?

God's ways are not our own. His plan can't be confined to a step-by-step formula. In that moment when things don't turn out like the picture we imagined, we have to step out on faith and trust that he's in charge. He has a plan for our lives that sometimes doesn't go according to our set of instructions.

We need to release our desire for control.

No matter how the cookie crumbles.

Lord, I place my faith in you. Give me peace when life doesn't work out the way I planned. Thank you for loving me, crumbles and all. Amen.

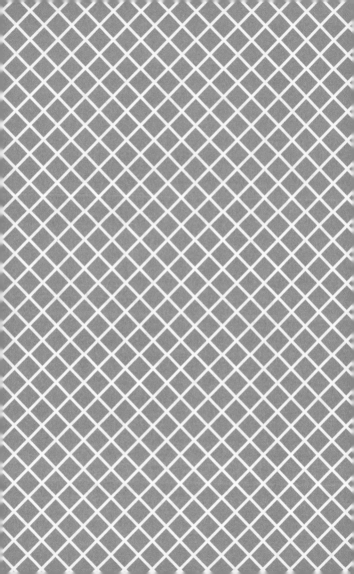

God's Got the How

*Israel's leaders took charge, and the people
gladly followed. Praise the LORD!*

JUDGES 5:2, NLT

HAVE YOU EVER BEEN ASKED to lead a group of
people?

It can be scary to be a leader. You want to say
yes, but you're nervous. You think you can do this,
but you're not sure. You understand the why and
the what and the where and the when of leading a
group. But then? You encounter the real challenge.

The how.

Deborah understood the challenges of leader-
ship. She was a prophet and a judge in Israel,

known far and wide for her wisdom and knowledge. As a judge, she sat under a palm tree, listening carefully to the disputes of individuals and rendering just verdicts.

At that time, the living conditions were terrible for the Israelites. They were being oppressed under the rule of Jabin, a Canaanite king. Every day Deborah saw the struggles of her people, and her heart was moved. She knew something had to be done. Someone had to free God's people and relieve their suffering.

Israel needed a leader.

Deborah was just the woman for the job. She received a message from God and wasted no time putting it into action. She instructed a warrior named Barak to gather ten thousand troops at Mount Tabor and attack the Canaanite forces. Barak was nervous. Barak was worried. He didn't want to lead the men by himself.

So he asked for Deborah's help.

After a fierce battle, Israel defeated the Canaanites. It was a miracle—after years of oppression, they finally had their freedom.

With God's help, the Israelites faced a mighty enemy and emerged victorious. They were the conquerors.

The most amazing thing about Deborah's leadership was her unshakable faith in God. She knew the why and she understood the what and the when and the where. But the how? The ins and outs of how a band of Israelites could defeat a mighty enemy?

Those questions might have defeated a lesser leader.

But Deborah didn't worry. She didn't waver. She didn't step back and analyze and discuss and waste time wondering about the battle plan. She knew that the battle had already been won. And she understood the most important part of a victory strategy: God had the how.

Taking on a leadership role can be overwhelming—even scary at times. But when God calls you to lead, you can step out in faith, not worrying about how to accomplish the task.

It's already in God's hands.

Lord, I give you my hows today. Give me the strength to fight my battles. Direct my path, and help me to turn my worries over to you. Amen.

I Can Sing Extra

Sing to the LORD a new song;
sing to the LORD, all the earth.

PSALM 96:1

BRACES ARE ONE OF the milestones of life.
I know. Our family just went through this.

My twin daughters were so excited to get
their braces on. They counted down the days and
talked to their friends about rubber band colors
and grinned at themselves in the mirror, trying
to imagine what they would look like.

Finally the day arrived. They got their braces
on . . . and then the pain started. For most of the
rest of that day and the next, they simply sat with

sad faces, sipping soup and holding their heads in their hands.

It broke my heart.

Later that afternoon, one of the twins came into the living room and curled up next to me on the couch. "I'm so sad, Mom." Tears welled up in her eyes.

"I'm sorry," I said, wishing I could wipe away every bit of the hurt. "Are you sad because your mouth hurts?"

"No." She sighed softly. "I mean, that's part of it, but that's not really what I'm sad about."

"Is it because braces aren't as fun as you thought they would be?" I asked. I was getting curious now.

"No, that's not it either. It's something so much sadder than that."

This was serious. This was sadness central. Suddenly she burst into tears. "Mom, you don't understand," she sobbed. "I was upstairs trying to sing my favorite song, and . . . and . . . I couldn't. Every time I tried to sing, I couldn't get the words out fast enough. I tried and tried, but my braces kept getting in the way."

I wanted to laugh out loud. I wanted to tell her that the braces would pass. I wanted to fix her some soup. But I didn't. Instead, I told her not to be sad, not to cry, and not to worry.

I could sing extra for both of us for a while.

The truth is, she's right. There are times when we can't sing our own song. Sometimes, when life overwhelms us and trips us up, it's so easy to question whether God is still good. The darkness surrounds us, and we feel so alone. Is God there? Is he listening? Can he hear our prayers?

But regardless of how we feel, God is here.

He hears our cries. He listens to our prayers. He knows every beat of our hearts. He surrounds us with his love and offers us his peace, no matter the circumstances. And when we can no longer utter a note?

He sings our song for us.

Lord, thank you for being there for me in every circumstance. I lay today's worries at your feet. Thank you for giving me peace. Amen.

Pulling the Hill Out from under Me

*The LORD upholds all who fall and lifts
up all who are bowed down.*

PSALM 145:14

LAST YEAR I spoke at a women's conference in North Carolina.

It was an amazing experience. I told story after story and twirled around onstage and chased verbal rabbits and talked about DIY projects for forty-five minutes. The session sped by in a blur, and suddenly it was over and I was shaking hands with attendees by the door.

I floated out of the classroom on cloud nine.

Bundling my supplies under my arm, I started

toward my car. It was a journey. The conference center was at the top of a high hill, and my car was parked at the bottom. To reach the parking lot below, there were two ways down: a long paved driveway and a short but steep grassy hill. Normally I would have chosen the safer, wiser, more stable driveway. But that day?

I chose the path less traveled.

I confidently made my way onto the slope of green grass that stretched before me. Smiling, I turned to wave at the conference attendees standing on the porch for the closing reception as I trekked down the hill. Feeling emboldened by their nods and waves, I took off faster through the grass until I was almost skipping.

Suddenly, one of my skips turned into a *whoosh* as my feet slid out from underneath me on the wet grass. I lost my footing and bounced the rest of the way down the hill, leaving a trail of mud behind me until I finally came to a stop next to the parking lot.

Maybe no one noticed, I thought. *Maybe I can*

climb quickly into the car without anyone seeing the giant mud spot on the back of my dress.

Just then applause erupted from the balcony. So much for a graceful exit.

At one time or another, we all fall. Maybe it isn't down a hill in front of people you've just spent forty-five minutes feeling amazing in front of. But whatever the circumstances, the falling often comes when we least expect it. A lost job. A phone call from the doctor's office. A word spoken in anger between friends. But with every fall?

God is there.

He lifts us up. He sets us on our feet and makes us whole again. Time after time he is there to catch us when we lose our footing.

Even on the hill less taken.

Lord, thank you for being with me in every situation. Thank you for catching me when I fall. I love you. Amen.

When His Plans
Are Impossible

We are God's handiwork, created in
Christ Jesus to do good works, which God
prepared in advance for us to do.

EPHESIANS 2:10

WHEN I STARTED A BLOG, I had no idea where I
was going.

I had no idea of the journey. I had no idea
how God would use a few hastily written lines
and a few forlorn pictures of my Christmas
decorations (minus the ever-essential tree skirt).
I never imagined where those URLs and hyper-
links and random decor tips would travel.

God knew.

He had a plan for the blog—something

I never imagined. Something I never even thought was possible. He used the blog to connect people across the globe and build a community of people who encouraged each other and laughed and learned together even though they'd never met.

Just like my blog with its awkward Christmas decorations, God had a purpose for Elizabeth, too. When we first meet Elizabeth in Luke 1, several things are immediately apparent. She was righteous. She was faithful. She was old. And perhaps most significant of all, she and her husband, Zechariah, were childless. Now that Elizabeth was well past her childbearing years, they had long since given up any hope of children.

And then a miracle happened.

An angel appeared to Zechariah and told him his wife would bear a son. And not just any son—a son who would pave the way for Jesus, the Messiah. Zechariah couldn't believe it. He was dumbfounded. *A son?* How could this happen? Could it be that he and his wife would actually have a child? It seemed impossible.

But God had a purpose and a plan that defied what is humanly possible.

Elizabeth gave birth to a son who grew up to be called John the Baptist. He was a source of joy and delight for his parents, and people everywhere rejoiced at the miracle of his birth. He traveled throughout the wilderness in Israel, calling people back to the Lord. He foretold the coming of the Messiah and prepared the hearts of the people to receive God's Word.

God's plans aren't just for people like John the Baptist; he has a purpose for all of us.

He has knitted each of us together in our mother's womb and has numbered every single hair on our heads. And as was the case for Elizabeth, sometimes the purpose isn't one we expect. Sometimes God grants a fulfilled dream where hope seems lost. Sometimes he turns an amateur's blog fumbles into a message about his love. And sometimes he pulls off something that seems almost impossible.

It's a good thing impossibles are part of the Master Designer's plan.

Lord, help me to understand the purpose you've created me for. Let me seek your will for my life. Help me draw closer to you. Amen.

Turning Up the Focus

You will seek me and find me when you
seek me with all your heart.

JEREMIAH 29:13

HAVE YOU EVER HEARD of the term *bokeh*?

It's a photography term used to describe the amount of focus on a particular object. You've probably seen it before and just didn't know what it was called. I didn't know at first either. I just accidentally blurred the background of one of my pictures one day and fell in love with all that fuzz.

Years later I learned that fuzz had a name: *bokeh*.

I once took a picture of a blue-ribbon ear of

corn on the cob with the best bokeh this side of the Mississippi. If you looked closely at the picture, you could see that part of the cob was perfectly focused—every piece of corn silk and every drop of condensation on the husk seemed to leap off the page.

But all around the corn you can see the beautiful fuzz. I spend hours trying to capture a background like that when taking a close-up of something. I use a 50mm lens and adjust the camera to capture the object with a shallow depth of field. The lens zooms in on one small part of the piece with a brilliant, sharp, crisp focus.

But everything else? The edges slowly but surely fade away until it's hard to make out the details in the rest of the photograph. The scenery fades into the background, becoming an insignificant part of the photo.

Wouldn't it be amazing if our lives were full of bokeh?

Wouldn't it be incredible if we were able to focus in with laser-like precision on what was truly important? Wouldn't it be so much simpler

if we placed God and his purposes for us squarely in the center of the frame? And then turned up the focus on him?

If we could focus our hearts like a 50mm lens, we'd be able to see him clearly. His Word and his promises would be front and center in the snapshot of our lives—perfectly, clearly, and sharply defined, without any distractions.

And then? All our daily distractions would fade into the background, in the fuzzy part of the photo that's out of focus. What was once important would be minor. What once pulled our attention away from God would become insignificant. The things of this world would simply fade away.

All with a little spiritual bokeh.

Lord, help me to turn up my focus onto you. Thank you for showing me daily truth through your Word. Please remind me of what's truly important. Amen.

I'll Share My Sweet Tea

I was hungry and you gave me something to eat,
I was thirsty and you gave me something to drink,
I was a stranger and you invited me in.

MATTHEW 25:35

I LOVE SWEET TEA.

I love sweet tea with ice. I love sweet tea with lime. But most of all? I love sweet tea with friends. If you drove down our road and turned in at the farmhouse, chances are I'd be sitting on the back porch with my hands waving, laughing, and telling a story to someone who stopped by for a little sweet tea and conversation.

This is Southern hospitality at its finest.

The Shunammite woman in 2 Kings 4

understood hospitality too. One day when Elisha the prophet was walking down the street in her town, the woman came out and invited him into her house for a meal. Elisha accepted and stayed to eat. Every time he visited Shunem, it was the same—hospitality and a meal at the woman's house.

And then? The woman extended her hospitality even more. She opened her home. She prepared a room and a bed so Elisha could stay there whenever he came into town. She understood this was a holy man of God. She understood the importance of his work, and she wanted to make him feel welcome in a strange place.

She offered hospitality without expecting anything in return.

But God repaid her hospitality to his prophet ten times over. Despite the fact that she and her husband were old, the woman gave birth to a son. A number of years later, the boy became ill when he was out in the fields with the reapers. As a result of his illness, he eventually died. The woman was despondent and turned to Elisha

who, with God's power, raised her son from the dead. Her faithfulness and her hospitality were greatly rewarded.

God calls us to offer hospitality to those in need. Romans 12:13 says, "Share with the Lord's people who are in need. Practice hospitality." It's important for us to recognize that all we have is God's. Everything we own is his. He has blessed us, and we are to open our doors and our hearts to others out of the overflow. Like the Shunammite woman, we're to offer what we have to those who need it.

Including a glass of sweet tea.

Lord, all I have is yours. Let me give it away to those in need. Help me to look for opportunities to offer hospitality to others. Amen.

Why Lions Should Never Somersault

Let us run with perseverance the
race marked out for us.

HEBREWS 12:1

I KNEW I WOULD BE the perfect lion.

Leo the Lion was our high school mascot, and the costume was amazing. It consisted of a giant lion head with a yarn mane, huge paws, and a furry lion outfit complete with a school T-shirt. At football games, the lion danced around and encouraged the crowd and mimicked the cheers. At every game, for five glorious minutes, the lion threw T-shirts and footballs into the crowd while everyone chanted the lion's name.

It sounded incredible.

I wasn't really coordinated enough by lion standards, but that minor detail was lost on me as I prepared for tryouts with frenetic enthusiasm. This was my moment. This was my time to shine. Attending football games wearing an oversized mane, here I come.

I spent hours perfecting the choreography for my tryout. It involved growling and shouting and cheering and climbing over a chair and finishing the entire routine with a combination hand wave and somersault.

I think I even drew whiskers on my face.

The day of tryouts finally arrived. One potential lion tried out and then another until finally it was my turn. I shouted and yelled and growled and even made the last-minute executive decision to scratch at the air in the middle of the cheer.

Suffice it to say, my choreography was amazing.

Until I went in for the big finish. I started a somersault, but somewhere along the way, I ended up on my side, sprawled across the floor with my mane askew and whiskers all over my

hands. I tried in vain to save the performance. I truly did. I rolled over and attempted to turn the fall into a catlike crawl off the gym floor. But no matter what I did, no matter how hard I tried, it didn't matter.

I wasn't going to be a lion.

How many times have we done something that failed and then tried to fix ourselves? How often have we ignored God's call or direction for our lives and decided that we knew what was best? How many times have we thought our plan was the better way?

In reality, this is the precise moment to turn the situation over to him. He knows our hearts. He's there in every situation, in every somersault, in every whisker-covered landing. God has the solution. God has the answer.

God's got you.

Lord, help me to remember to seek your will. Remind me that my ways are not your own. Thank you for always being there for me. Amen.

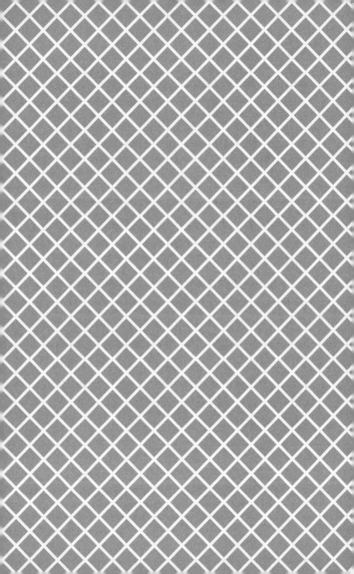

The Birthday Candle
That Lit Up the World

The people walking in darkness
have seen a great light.

ISAIAH 9:2

WHEN YOU LIVE IN THE COUNTRY, there's always a storm around the corner.

We've been through flash floods and the tip of a hurricane and hailstorms and ice storms and thunderstorms that fill the sky with lightning so brilliant it looks like it's been choreographed. You learn to be prepared.

After the first storm, we discovered the importance of having a kit ready. Our kit is filled with the essentials—flashlights and candles and batteries and ice scrapers and a deck of cards.

A game of Spades is essential in the middle of a storm.

The other day, heavy thunderstorms rolled in, and within minutes the lights went out. We weren't worried. We weren't scared. We were prepared. We had our kit.

Except.

Except we couldn't find it. Someone had misplaced it during the last flash flood. It was gone. We were all alone in the middle of the darkness, without a candle to our name.

Have you ever seen darkness in the country? When you're surrounded by fields and hay and rolling meadows, the dark is extra dark. You can't even see your hand in front of your face. I stumbled around in the darkness trying to find something to shine—something to shed a little light on the situation. As I blindly searched through the junk drawer, I found it.

A single birthday candle.

As I struck a match and lit the candle, brightness flooded the kitchen. All that light. All that

brilliance. All that illumination. All from one tiny candle.

That's what our heavenly Father calls us to be. He instructs us to be a light to those around us. Jesus tells us in John 8:12, "I am the light of the world. Whoever follows me will never walk in darkness, but will have the light of life."

We live in a world full of darkness. Sin and sadness are all around us. The only way to combat darkness is with his light. We may worry that our light isn't that bright, but we don't have to have the strength of a giant beacon. God uses even the smallest of lights. He uses even the tiniest birthday candle. All we have to do is open our hearts and let our light shine.

We can trust God to do the rest.

Lord, thank you for showing me the way. Let me be a light in this dark world. Help me to shine your light to everyone around me. Amen.

All we have to do is
open our hearts and
let our light shine.

We can trust God
to do the rest.

About the Author

KARIANNE WOOD writes the decorating and lifestyle blog *Thistlewood Farms* from her project-filled historic home in Dallas, Texas. She recently followed God's call and jumped back "home" with her family from the middle of the country to the busy Dallas metroplex where she lives with her husband and four children.

If you wander down the tree-lined streets of KariAnne's beloved hometown, McKinney, you might find her painting mismatched chairs, listening to Christmas carols no matter the season, singing Scripture, or walking hand in hand with her knight-in-shining-armor husband to a Friday night football game. She loves sweet

tea with lime, thunderstorms, good books, milk glass, and yard sales, and she is an imperfect DIYer saved by grace.

Thistlewood Farms is full of stories of family and faith and features hundreds of the home decor projects KariAnne creates every week for readers. The blog was awarded the *Country Living* Decorating Blog of the Year, was named one of the Top 10 Decorating Blogs by *Better Homes and Gardens*, and was voted one of the best DIY blogs of 2015. KariAnne has been featured in *Better Homes and Gardens Christmas Ideas*, *Country Living*, *Flea Market Décor*, *Country Woman*, *HGTV Magazine*, the *Cottage Journal*, the *Chicago Tribune*, *Reloved*, and *This Old House* magazine, and on popular websites including the *Today* show, *Better Homes and Gardens*, *Country Living*, *Apartment Therapy*, *Good Housekeeping*, *Mediakix*, *Bob Vila*, and *BuzzFeed*. KariAnne has made appearances on television programs including Nashville Channel 5's *Talk of the Town* and Channel 8 in Dallas.

Decorate with Confidence

KariAnne has created this delightful and inspiring home planner to guide you on the decorating road ahead. *The DIY Home Planner* is packed with unique features to help you realize your decorating dreams:

ILLUSTRATIONS, PHOTOS & DIAGRAMS

EASY DIY PROJECTS

CONVENIENT POCKETS

TEAR-OUT EXTRAS

DEFINITIONS, FORMULAS & GUIDELINES

Discover these and other amazing tips in every area of home decor!
www.DIYHomePlanner.com

AVAILABLE NOW
FROM HARVEST HOUSE PUBLISHERS

CP1374